CCC ART

REIMA VICTOR RATTI

CCC ART

Artists of the Civilian Conservation Corps

REIMA VICTOR RATTI

by KATHLEEN DUXBURY

ISBN 978-0-9860038-7-5
Library of Congress Control Number: 2018909085
BISAC: History / United States / State & Local / Great Lakes
Printed in the United States of America
This work was designed, produced, and published in the United
States of America by

Duxbury Media, Inc.
Kathleen Duxbury Yeaw
Ridgewood, N.J. 07450

Website:

kathleenduxbury.com
newdealstories.com
e-mail: cccstories@gmail.com

The author and publisher welcome comments and corrections, at the
above e-mail address, in regard to the documentation in this work.

The views expressed are solely those of the author. Any errors or
omissions in this book are not intentional and are the responsibility
of the author.

Dedication

To my parents who guided me,

to Mary who loved the artist and treasured the art,

and to Gardner—naturally.

Also by Kathleen Duxbury

Marshall Davis, CCC Art—Artists of the Civilian Conservation Corps

The Boys Of Bergen: Remembering the Civilian Conservation Corps in Bergen County, New Jersey

Contents

Introduction

Every Civilian Conservation Corps (CCC) camp has a history, and every CCC artist has a story. What makes the narrative of CCC artist Reima Victor Ratti compelling is his adventures big and small, his hardships and hard-won successes, his friendships and devotion, and, most importantly, a legacy of his artistry, which the public can see today.

He was born into a loving immigrant family in Waukegan, Illinois, during a month and year that ushered in change to the world order with the advent of World War I. The future was unpredictable for this first generation of Americans, but in Lake County, Illinois, there was hope and seeming prosperity for the young Ratti family.

The birth of first son, Reima, or "Ray," as he was known to friends and family, was a "ray" of sunshine. He came of age during the 1920s in an industrial port city on Lake Michigan, a period described for a young boy as "ideal." Nationally acclaimed author Ray Bradbury, a Waukegan native, would pen a idyllic description of a boy coming of age in 1920s "Green Town."

During Ratti's public school years, the educational programs in Waukegan schools were well-established. The art educators had advanced college degrees and provided remarkable guidance and instruction. Ratti was among an outstanding group of aspiring art students who benefited greatly from these dedicated teachers. He would avail himself of every artistic opportunity: day and night classes offered in the cities and counties; competing for and winning an art scholarship by the Art Institute of Chicago; and museum art training funded by the Works Progress Administration (WPA).

The talons of the 1930s' Great Depression did not bypass the Rattis. They keenly felt the disabling grip and loss created by the economic downturn. This was also the era when people suffered and died prior to the discovery of the miracle antibiotics. The timing was especially cruel as Ratti completed his public education and plunged into a nonexistent workforce.

He joined the CCC as a regular laborer in an effort to help his family and himself. In the CCC, his work ethic and artistic talents were recognized and encouraged. Ratti applied for and was accepted into the CCC Art Program where he flourished. Depictions of the CCC rock-crushing labor and fire-fighting experiences would continue to surface in his art.

Ratti was a versatile talent, experimenting in different mediums, including sculpture. He lived for his art and would find meaningful employment, love and purpose when he returned to Waukegan.

But time would run out.

As a regular CCC enrollee, he sculpted a figure that symbolized a typical CCC enrollee and titled it *Days Work Done—C.C.C.* He sold the statuette as a souvenir while still in the CCC. Decades after Ratti's death, fate would intervene. The unidentified statue resurfaced and was used as a model for a life-sized bronze monument, now known as the the *CCC Worker* statue, which has been reproduced.

Since the 1990s, *CCC Worker* monuments have continued to be erected in state and national parks. They stand in recognition of the accomplishments and contributions of 2 million CCC enrollees and the greatest conservation movement in American history. The *CCC Worker* sculpture, considered by those who lived it, represents the ideal CCC enrollee, a design inspired decades earlier by CCC artist extraordinaire Reima Victor Ratti.

Forward

I first met Kathleen Duxbury in September 2010 when she was researching Civilian Conservation Corps (CCC) artists. Kathleen had found my blog post on Reima V. Ratti and was thrilled to discover another artist in President Roosevelt's New Deal CCC art program, and that the Bess Bower Dunn Museum of Lake County had a collection of Ratti's work.

Kathleen's keen interest in the CCC art program was infectious, and as the curator and Lake County historian for the Dunn Museum, I was intrigued by her insights into a national story with a local connection. Her professional research and passion for her subject have revealed a complex story of a Finnish immigrant family struggling through the Great Depression, and a young man's efforts to support his family while pursuing his love of art.

Reima V. Ratti created art to lift himself and those around him out of the gloom of a worldwide economic depression, and his artistic contributions to the Civilian Conservation Corps art program placed him in the path of history.

There is no one better to tell his story than Kathleen Duxbury.

—Diana Dretske,
museum curator and Lake County historian,
Libertyville, Illinois 2018,
and author of *Lake County Illinois: An Illustrated History*
and Images of America: Fort Sheridan

PART I

CIVILIAN
CONSERVATION
CORPS

Chapter 1

Defining the CCC

*These young men (CCC enrollees) come from the ranks
of those who have been almost universally deprived of
the American Citizen's normal right—the chance for
self-support and self-development. They represent that
great number of American youth who have arrived
at working age and found absolutely no opportunity
for employment. These young men are heartsick and
disappointed.[1]*

<div align="right">

W. Frank Persons,
Labor Department CCC representative

</div>

When Franklin Delano Roosevelt became the 32nd U.S. president
March 4, 1933, the country was in the fourth year of the crippling
Great Depression. FDR knew he was facing a nation crushed by
an economic crisis. It would be months, though, before he and his
administration began to understand the true depth and reach of the
unemployment disaster. While campaigning and in his inaugural
speech, FDR addressed the grinding poverty and despair by prom-
ising to remedy it with a New Deal for the American people. His
remedies would be experimental.

Unemployment figures gathered by Secretary of Labor Frances
Perkins were staggering: Nearly a quarter of the country's civilian
population was unemployed, more than 14 million people were
out of work, and it was getting worse. Among this number was a
group most vulnerable and hardest hit by the decline, the idle youth
between ages 18 and 25. These young people were a generation with
little to no prospects for employment, they were floundering and in
danger of becoming a hobo generation. FDR proposed the first of his
New Deal work programs as a way to address this rudderless group.
The program was originally titled Emergency Conservation Work
Act (ECW), but FDR preferred to use the designation of the Civilian
Conservation Corps (CCC). The name was officially changed by act
June 28, 1937. Within months, he would add two more groups to the

CCC program: struggling war veterans and Native Americans on their reservations. Sixteen months later, he would approve yet another group of enrollees: idle artists.

The economic and unemployment crisis was not the only danger facing the nation There was an environmental calamity, which was partially manmade. Decades of clear-cutting timber and poor farming practices left the soil, water and trees depleted. Erosion, floods, insect infestation, and wildfires were destroying and washing away topsoil that once produced abundant crops and nurtured dense forests. In the late 1920s, a prolonged drought began that withered and dried up the plains and prairies where the winds always blow. This resulted in a perfect storm that created huge swirling, destructive, depleting masses of dirt, the phenomenon now known as the Dust Bowl. There was a reasonable fear that America was blowing and floating away.

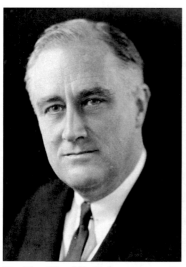

President Franklin Delano Roosevelt

On March 9, 1933, five days after taking office, President Roosevelt called an emergency meeting of his Cabinet to outline his idea for a reforestation program. He instructed the secretaries of War, Interior, Agriculture and Labor to draft a proposal that he would present to Congress. He wanted a bill that would "take the unemployed men out of the crowded areas and put them to work in the national forests." The bill would apply only to public works that would not otherwise be undertaken at this time of financial stringency.[2]

More than any other New Deal agency, the CCC is considered an extension of Roosevelt's personal philosophy, and with this act, he brought together two wasted resources—young men and the land.

Roosevelt's intention was to utilize existing government bureaus to carry out the plan while stressing that this was a reforestation program that would confine itself to prevention of soil erosion, flood control, and similar projects. His initial proposal called for recruitment among all the nation's unemployed. This would be modified

to include only single young men and, later, World War veterans. They became a volunteer forest army that battled the erosion and destruction of the nation's natural resources. Many had no idea what conservation was. They were unemployed, unskilled and qualified for relief. Most would say that they did it to help their families.

During the early days while framing the program, the president learned labor people were upset the Army would be in the picture. FDR insisted the Department of Labor take charge of the CCC. This directive tasked Frances Perkins, his newly appointed secretary of Labor with an enormous responsibility.[3] Her memoirs and subsequent oral history interview, recorded decades later, provide a window into those frenzied days of the early Roosevelt administration.

Architect of the CCC — Frances Perkins

Long before Roosevelt occupied the Oval Office, the administrative and ideological attitudes of FDR and Perkins had intersected, melded and seemingly became one. Their professional partnership was strengthened during Roosevelt's term as governor of New York from 1929 to 1932. Roosevelt recognized Perkins's understanding and grasp of complex government policies, and he appointed her commissioner of the New York State Industrial Commission. In this position, Perkins supervised the health and safety of state workers, an appointment she managed with little difficulty. As a seasoned social worker, activist for public works, child labor, unemployment insurance, and workers' rights, Perkins was able to tutor the governor on the concept of "social insurance."[4]

When FDR became president, he selected her to be secretary of Labor, the first woman appointed to a U.S. cabinet position. Her tenure, as one of his closest and trusted advisers, would span FDR's four-term administration. Perkins was in a unique position to observe,

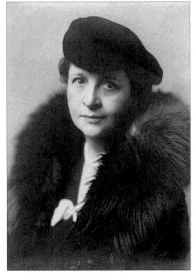

Frances Perkins served as secretary of Labor from 1933 to 1945.

assist and analyze FDR—"the most complicated human being I ever knew."

Perkins likened the president's method of getting things done, "to put dynamite under the people who had to do the job and let them fumble for their own methods."[5]

> *This great brainstorm about giving the unemployed relief by taking them out into the woods to do forestry work. I first heard about this from the mouth of Franklin Roosevelt, without any preparation at all. . . I thought it was a pipe dream. . . Already my mind had begun to work on who the unemployed were, how you were going to get them to the places where they were going, how they would know what to do when they got there. . . He thought you could just take everybody who was applying for relief and put them in the forests . . . He just thought of all the unemployed, not just of the young men. The young men were my idea later.. . .[6]*

> *It was very complicated. I said, "How are you going to recruit? If you're going to pay them money, how are you going to get them?" He said, "Use your employment service." I said, "Mr. President, we haven't got an employment service . . ." He said, "Make one. Create one." By this time, I began to throw in some other ideas.[7]*

It was agreed that the forest work projects should be directed by the Departments of Interior and Agriculture. Perkins collaborated and consulted with George Dern, secretary of War, and brought in W. Frank Persons as the Labor Departments CCC representative. Persons possessed invaluable insight because of his World War I Red Cross experience.

> *He knew how to handle an organization which was nationwide and which had to be alerted at a moment's notice for disaster relief or special relief in emergency quarters. This was an emergency operation, all right.[8]*

Secretary of Labor Frances Perkins found support and guidance when she teamed with W. Frank Persons (left), and Secretary of War George Dern (right). She felt they were invaluable to the successful formation and organization of the CCC.

With the counsel and cooperation of Dern and Persons, Secretary Perkins was able to advise the president:

> *"What do you think about this? We've got a big military establishment in this country. It isn't busy. It's a stand-by organization. They must have trucks. Mr. President, they must have tents. They must have cots. They must have blankets. They must have shoes. They must have a lot of things. Why can't we use that?"*
>
> *He said, "Why, that's brilliant idea. I never thought of it."*[9]

Roosevelt called it the Civilian Conservation Corps. "We'll call them civilians. These are not military people."

It was Perkins who "had to go up on the Hill and testify as the principal representative of the President in this field, explaining to Congress before whom the bill was to be heard."[10]

Her first appearance before a large congressional committee was March 23, 1933. The attendance of First Lady Eleanor Roosevelt added to the interest and crowds of newspapermen, women and photographers. When Perkins stood before the committee to testify, the chair she had occupied while awaiting her turn was quickly taken by a spectator.[11] Her testimony, given under sweltering klieg and flash lights, dragged on for close to two exhausting hours."[12]

When the session was over, Perkins learned that her testimony was well-received, though she recalled one congressman had said, "that I'd made a good appearance, but he'd hate to be married to me."[13]

CCC Bill Passes

Senate bill S. 598 authorizing the Emergency Conservation Works (ECW) program was introduced March 27, 1933. The measure passed both houses of Congress and was on the President's desk to be signed March 31, 1933. FDR gave his formal approval with Executive Order 6101 on April 5, 1933.

Big Boss Proud of Boys
Holds Record of Men in Woods
As Example to Newcomers

ROBERT FECHNER

Robert Fechner,
CCC Director, circa 1936

FDR ordered that a quota of 250,000 men be put to work in CCC camps by July. It was a massive undertaking. On April 17, 1933, less than five weeks after FDR put the idea in motion, the first camp, Camp Roosevelt in the George Washington National Forest in Luray, Virginia, was occupied.[14]

Robert Fechner, vice president of the machinists union, was wisely appointed the first director of the CCC. He joined representatives from the four cabinet agencies: War, Interior, Agriculture, and Labor. Cooperation among these agencies was vital for the implementation the program.

When someone complained that this complicated setup would not make for efficient administration, Roosevelt, who was not troubled, replied, 'Oh that does not matter, The Army and Forestry Service will really run the show, the secretary of Labor will select the men and make the rules, and Fechner will "go along" and give everybody satisfaction and confidence.' "[15]

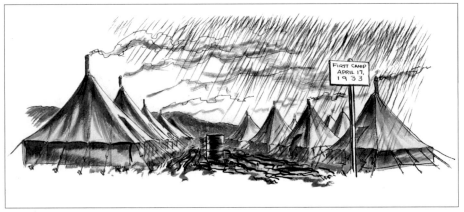

The first CCC camp set up in Luray, Virginia, is depicted by former CCC artist Marshall Davis for the CCC *Camp Life Series 1939–1940*, published by the Office of Education.

Agencies and Responsibilities

Department of War would shoulder most of the responsibilities through the Army, which mobilized the national transportation system and moved thousands of enrollees by truck and rail from induction centers to working camps. The Army, with its nine corps areas in the United States, was the only agency equipped to handle the physical maintenance of the camps and enrollees, which included health care, sustenance, communication, supplies, shelter, and transportation. Recruits who passed the physical were enrolled as Juniors, inoculated against smallpox and typhoid and transported to various Army bases where they were assigned to a company. After a short period of conditioning, they were transported to a CCC work camp.

Department of the Interior was in charge of CCC camps in National Parks, on Indian reservations, and in U.S. territories, including Hawaii, Alaska, Puerto Rico, and the Virgin Islands. The Interior Department's Office of Education appointed a director of CCC education, who appointed advisers in the nine corps areas.

Department of Agriculture administered the U.S. Forest Service and was responsible for work done on private lands and state forests.

Department of Labor was responsible for rules of selection and approval of enrollees; this was managed through the local offices of each state's relief organization.

Civilian Conservation Corps (originally called the Emergency Conservation Works ECW) was a separate department that

coordinated with all other agencies in administering the program. They had their own education section and a nationwide division of camp inspectors.

The inspectors' detailed reports insured compliance and protected the interests of the CCC enrollees, in addition to dealing with complaints and accidents. The CCC agency monitored and reported on the programs accomplishments, safety, strength and goals.

Veterans Administration received a quota for the selection of World War I and Spanish-American War veterans.

CCC Indian Division was a flexible program, which had no association with the Department of War. It was administered through the Department of Interior and evolved to fit the needs of Native Americans. Their circumstances were different from other enrollees; tribal councils worked in cooperation with a superintendent and local forestry representatives to outline projects specifically for the needs of the reservations. Local Indian agencies selected enrollees who had no age or marital restrictions; they were not limited to a maximum term of enrollment.[16]

Treasury Department administered a special program through the Section of Painting and Sculpture called the CCC Art Project, active between 1934 and 1937. A maximum of 100 artists were authorized for enrollment, one per camp per enrollment period. Their purpose was to make a pictorial record of the CCC life and work and their rank was artist/enrollee. Initially, artists had no age, marital restrictions, or relief requirements. In 1937, however, Congress voted to limit the age of regular enrollees to 29 years, which led, in part, to the demise of the program. Artwork created during the 40-hour work week became the property of the U.S. government.

Illustration by Davis for the CCC *Camp Life Series, 1939–1940.*

The various work projects of the CCC camps were dependent upon the needs of their locations. In Dust Bowl regions, soil-erosion prevention projects were started. Other regions required reforestation projects, access roads, trail building, park improvement, telephone lines, fire towers, mosquito and other insect control, and construction of public recreation areas. In Wisconsin, controlling the floodwaters from the Milwaukee River was a priority, and in Michigan during the summer of 1936, the CCC would answer the call for extensive emergency firefighting.

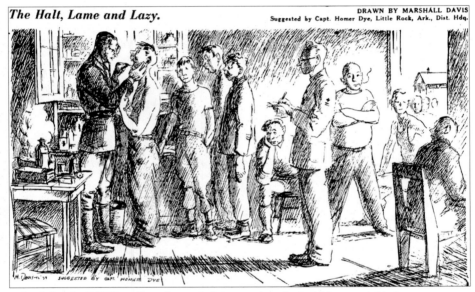

After daily roll call, CCC enrollees who sought deferment from the day's labor reported to the camp medical officer for examination.

A typical camp was comprised of a company totaling 200 men. It included a company commander and assistant commander—originally commissioned Army, Naval, and Marine officers brought in from the War Department. In time, these commissioned officers returned to their military posts. New CCC commanders were taken from the rolls of thousands of military reserve officers, many from World War I or the newly graduated classes of the Reserve Officers' Training Corps (ROTC). A camp would have a doctor, either assigned from the War Department or contracted locally.

Each camp had a nonmilitary superintendent who supervised the work projects and managed the quota of technical staff required to

run the camps. This staff overhead factored into about 15 percent of the total company strength. The staff included men permanently employed as leaders, assistant leaders, cooks, blacksmiths, mechanics, carpenters, surveyors, masons, landscapers and forest personnel. They were designated Local Experienced Men (LEMS). It was desirable that LEMS be employed from nearby communities.

Local farmers and shopkeepers welcomed the business generated by the needs of the camps. Items purchased nearby were dairy, produce, and other perishables, thereby supporting and stimulating the local economy. The benefits derived from the needed employment and capital helped

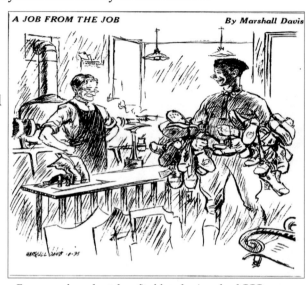

A JOB FROM THE JOB By Marshall Davis

Farmers and merchants benefited from having a local CCC camp.

garner acceptance and support in communities that saw a sudden influx of young and energetic CCC enrollees.

Eventually, each camp was assigned an educational adviser, who arranged for academic and vocational training in addition to arts and crafts, photography, and journalism classes, which produced camp newspapers and gave many CCC boys their start in publishing.

Initially, CCC boys received $30 a month, with $25 sent home to a dependent family member. If there were no dependents, the allotment was kept until the enrollee's discharge from the corps. Enrollment was voluntary and lasted for six-month periods, with a maximum of four tours. A CCC boy was eligible for an honorable discharge if there were a family emergency or if he could document employment.

There were no jailhouses; infractions or elopements were dealt with by demerits, KP duty, fines, or dishonorable discharge. CCC boys were required to work 40 hours a week, for which they received housing, food, clothing and medical and dental care. Their

transportation to and from the camps, upon admission and discharge, was provided by the Army. Sunday was a day of rest. Local clergy would visit the camps, or the enrollees were taken to town for services.

Activities and recreation were arranged with the goal of keeping morale up and satisfying a high-spirited contingent of physically fit young men who were always hungry. Sports competitions between camps were popular, especially boxing. A well-stocked library, nightly educational classes, and, when possible, vocational classes with the local school district, were offered. The boys were encouraged to enroll in these and other educational courses (mechanics, radio, typing) with the goal of learning a trade or talent that would serve them after their CCC service.

Weekly dances and movies were organized and held in the camp recreation building, the most popular camp structure, aside from the mess hall. In this simple building, amid the noise of poker, Ping-Pong, and innumerable bottles of Coke, or an occasional beer, many lasting friendships were fostered.[17]

CCC workers had to observe military-style living quarters and rules; they assembled in the mornings for roll call and then were led as a group to the mess hall in formation. In the evenings, they observed the "lights out" principle. They were required to get passes and permissions for any comings and goings.

"Despite the best intentions of all concerned, the enrollees were militarized by their association with the Army. This benefited the United States immeasurably" considering that 75 percent of the enrollees later served in the armed forces during World War II.[18]

WE CAN TAKE IT! was the CCC motto

circa 1935

circa 1941

WE CAN TAKE 'EM!

Artist Davis also designed World War II postcards., which were clearly influenced by his CCC artwork.

Accomplishments of the CCC

The CCC lasted nine and a half years, from April 5, 1933 to June 30, 1942, ending only after the United States entered World War II and the FDR administration's focus changed. Attempts to make the CCC a permanent agency were no longer viable, the country was at war, and funding required an affirmative vote from a Congress that still considered it a temporary relief organization.

The CCC created 800 state parks and improved hundreds of others by building thousands of public recreation areas. This included trails, pavilions, lodging, swimming pools, park roads, in addition to improvements and historic restoration in national and military parks. Soil, water, and forest erosion was arrested on more than 20 million acres, 3 billion trees were planted, more than 3,000 fire towers were constructed and 97,000 miles of fire roads were built. Other conservation efforts contributed to the protection of habitats for wildlife, stream improvement, restocking of fish, disease and insect eradication threatening the parks and forests, and building small dams for water conservation. In addition, the Bureau of Agricultural Engineering worked with Native American enrollees who performed construction work on 84.4 million acres of good agricultural land that was dependent on the manmade drainage ditches.[19]

The CCC enrolled 3,463,766 young men, war veterans, Native Americans, and artists; their paychecks benefited approximately 12 to 15 million people. The nonenrolled personnel and communities helped by the unexpected career opportunities, employment, trade, and improvements numbered in the hundreds of thousands. [20]

Davis's art was used to illustrate the 1935 booklet *We Can Take It*, a story of the CCC by Ray Hoyt.

Government Patronage of the Arts Through Other Alphabet Agencies: PWA, FERA, CWA

After establishing the CCC in April 1933, FDR and his adminis-
tration focused on the growing unemployment crisis. They sought
ways to create jobs that would generate other employment. This,
they theorized, would stimulate the economy and ease the economic
decline.

Public Works Administration

Two new agencies were formed. One was the Public Works
Administration (PWA), which followed FDR predecessor President
Herbert Hoover's design for large construction projects, such as the
already begun Justice Department building in Washington, D.C.
Numerous large-scale construction projects would follow, among
them the New York Triborough Bridge (now the Robert F. Kennedy
Bridge), San Francisco Golden Gate Bridge, Washington State Grand
Coulee Dam, along with major warships for the Navy.

Federal Emergency Relief Administration

The second agency created was the Federal Emergency Relief
Administration (FERA). Its goal was to relieve household unemploy-
ment with work. Most of the funds allocated for FERA were distribut-
ed directly to those most in need. But FERA had another component:
to loan money to the states that then joined with local governments
to create unskilled jobs. The FDR administration felt that doling
out relief money, without earning it, was a blow to an individual's
morale. FERA's make-work projects amounted to raking leaves in
local parks, digging ditches, and other forms of manual labor. These
jobs were widely considered demeaning. However, during the first
months of the FDR administration, FERA projects were a ready fix to
a mushrooming and overwhelming relief problem. FERA meant to
give people aid they could accept with dignity.

During the turbulent summer of 1933, FDR and his inner circle
came to realize that the middle classes, the trained, the professionals,
the educated—namely, artists, musicians, nurses, teachers, doctors,
architects, actors, writers and tradespeople—were succumbing to

A depiction of professional careers by Davis was published in the CCC *Camp Life Series 1939–1940* workbooks promoting continuing education.

the prolonged economic crisis. It was the fourth year of the Great Depression. Names of those who had never before stood on a breadline or asked for relief were now being documented by the Labor Department. The administration observed a record rise in professional classes applying for the menial FERA relief work. The applicants were people of accomplishment, capable and more than willing to work but unable to find jobs. Their savings, which may have seen them through the early years of the Depression, were now exhausted . . . they could no longer rely on family, community, or charities for support.[21] There was a tremendous talent pool going to waste; a decay of self-worth and cultural enrichment. This was not only damaging to mind and spirit, it was potentially dangerous.

Another Davis illustration in the CCC *Camp Life Series 1939–1940* underlined the importance of further education to help enrollees face the home and family responsibilities they were likely to encounter after their time in the CCC.

Civil Works Administration

A new program was quickly devised, although it was temporary and lasted only a few months. It would help 4 million Americans who would have festered in humiliation and idleness had the government not intervened.[22]

The Civil Works Administration (CWA) was a work program meant to provide nonrelief and meaningful employment to those unable to find jobs. It was a lifeline for many professionals who, in

turn, educated those able and willing to learn. The program was highly criticized, partly because of its enormous expense, but it aided thousands through what had accurately been predicted as the long, cold, and harsh winter of 1933–1934; in New England, temperatures plunged to 56 degrees below zero, and in Washington, D.C., thermostats registered a bone-chilling minus 6 degrees.

Contained in the guidelines of the CWA program was funding for another project that would support the arts and unemployed artists, aptly named the Public Works of Art Project (PWAP). The theme of the art project was "The American Scene." There were five guidelines; one was the inclusion of a pictorial record of the current government work programs, most specifically the CCC.[23]

By the time logistics were organized in late January 1934, the country was deep into a crippling winter, travel was limited. Only 40 PWAP artists, in mostly southern regions, were able to complete a pictorial record of the CCC before funding ended in April 1934. Many picturesque CCC districts of America went unrecorded but the foundation for another government sponsorship, the CCC Art Program, was established.

Artists were sent to CCC camps to create a pictorial record of the life and work through the federally sponsored Public Works of Art Project. This unusual New Deal program was explained in the CCC national newspaper, *Happy Days*, February 3, 1934.

Happy Days Newspaper

Happy Days was the unofficial but sanctioned newspaper of the CCC. It first published May 20, 1933, within weeks of the CCC organization, and was widely circulated in the camps. It was so well-received that within two months 500,000 copies were printed per week, costing five cents, three cents in the camp exchanges, or a yearly subscription for one dollar.[24] Its owners were Melvin Ryder and Ray Hoyt. Ryder, a former regimental sergeant major in the American Expeditionary Forces in France during World War I, had been on the staff of the famous World War I newspaper *Stars and Stripes*. Ray Hoyt was from Ohio and was the former city editor for the *Columbus Dispatch*.

They produced a newspaper that promised, in its first edition, to be a publication that would tell the stories of the CCC by the CCC, using an "honest policy of (good) cheer and giving you the dope."

President's Suggestion — CCC Artistic Depictions

When the PWAP projects ended April 26, 1934, thousands of artists again found themselves without work. Edward Bruce, director of the now ending PWAP and an accomplished painter and savvy businessman, knew there was little to offer struggling artists during the summer and fall months of 1934. He approached CCC Director Robert Fechner with an idea to continue the artistic depiction of the CCC. Bruce stated that artists from the prior PWAP program reported a keen interest by the CCC boys, who placed persistent demands on the roving PWAP artists to teach them how to draw and sketch.

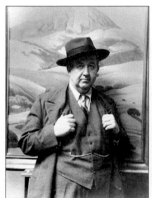

Edward Bruce

Bruce noted a significant number of pieces created in CCC camps had been included in a successful exhibit at the Corcoran Gallery of Art; an oil painting, depicting the lumbering at a CCC camp, was selected for display at the White House; and other pieces of CCC art were circulating the country in well-publicized museum and state

exhibits. Bruce suggested artists be sent to CCC camps with the status and pay of technical teaching staff, paying $165 a month.[25]

CCC Director Fechner, by his own admission, knew little about art, and those close to FDR would later reveal that the President did not necessarily have an eye for it, either. Fechner was open to Bruce's proposal and approached the President with the idea. Clearly, FDR and Fechner recognized the good publicity that could be derived from the project, the national park system had been anxious to acquire quality art to be used in park posters promoting tourism.[26] Resuming the depiction of the CCC, which was now the most popular of the New Deal programs, was good for business. However, there were politics that might interfere with the government's support of artists.

Employment of CCC Artists

On May 22, 1934, President Roosevelt met with his executive council. This council consisted of members of the Cabinet and heads of certain agencies. They routinely met to advise and report to the President on activities of federal agencies with respect to economic recovery. CCC Director Fechner discussed Bruce's proposal and asked for FDR's approval. The official records of this council meeting do not contain any documents mentioning a discussion of employing artists in CCC camps, perhaps because FDR did not allow records or notes to be made during his private conversations. However, archived with CCC Director Fechner's official records is a brief letter he sent to PWAP Director Edward Bruce later that day.[27]

Director Fechner informed Director Bruce that after some discussion, the President authorized him to say that he would approve the employment of a limited number of artists who would enter the corps with a standing equal to that of regular enrollees, receiving similar benefits, they were to receive the full $30 monthly allowance, and they would absorb the expense of their art supplies. Essentially, Fechner told Bruce the President's suggestion was a take-it-or-leave-it adoption of his proposal and the president had no desire to go further on the matter. Director Bruce was disappointed, as were regional PWAP art directors who suggested "the ante would have to be raised before" they could get anyone interested.[28]

In June 1934, the War Department dispatched a directive to all commanding generals in the forty-eight states' nine Corps areas:

Subject: Enrollment in C.C.C. of Artists

These men will be under the technical direction of the respective camp superintendents. They are not to be employed at labor or fatigue (duties) but are expected to devote 40 hours a week to their art. They are required to furnish their own drawing and painting materials. Their work becomes the property of the United States. They are not eligible for appointment as leaders or assistant leaders. They will be furnished transportation from their homes to the work projects to which assigned and return transportation at the time of their discharge.[29]

Later, dispatches would include directives that the artists would be granted the privilege of reenrolling for the next enrollment period that would begin October 1, 1934.

CCC Artists were assigned and administered by a special section within the Treasury Department; the purpose of this unusual government art project was best understood by Edward Beatty Rowan, the person who worked closest with the CCC artists.

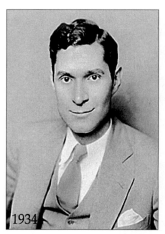

Edward Beatty Rowan

I want to stress to the artists that the purpose of sending them to these camps is to secure a pictorial record which will be of some value not only at the present, but in the future, of the life and activities of these camps.[30]

Edward B. Rowan, Chief, Treasury Department,
Section of Painting and Sculpture,
November 16, 1934

Advocate and Mentor Edward Beatty Rowan

Rowan, himself an artist, gallery director, and teacher, was assistant technical director of the Treasury Department, Public Works of Art Project (PWAP) and would later become the director of the Treasury Section of Painting and Sculpture (the Section).

Among Rowan's responsibilities after June 1934 was the selection, approval and monitoring of the CCC artists. He coordinated with the Department of War Office of the Adjutant General to assign and place artists in the camps. Rowan, who saw the quality of art accurately sensed the historic nature of this special art project, and felt that "although the average layman may not understand . . . in time the entire group (of CCC art) will be regarded as a most important record of the aims and aspirations of this exciting period."[31]

CCC artists were instructed to ship all movable art to the Treasury Department in Washington, D.C., from there it would be allocated to government offices, schools and taxpayer-funded organizations.

Rowan offered the artists guidance when critiquing their work. He would praise, admonish and encourage them, and he requested they write him of their camp experiences. To many artists, Rowan became an adviser, mentor and friend.

The CCC artist program employed more than 350 idle artists. Just as Rowan predicted, their art is of tremendous value because what they depicted was the greatest conservation movement in American history.

The first CCC artist enrollees received their assignments July 3, 1934. Some stayed at the camps a few days, and others were with the program until it ended three and a half years later, September 30, 1937.

Among them was a young, untried artist from Waukegan, Illinois, Reima Victor Ratti—"Ray" to his friends and family.

His artistic association would prove to be the inspiration for a monument design that has become known as the *CCC Worker* statue. The sculpture can be found in state and national parks that benefitted from the work of the CCC.

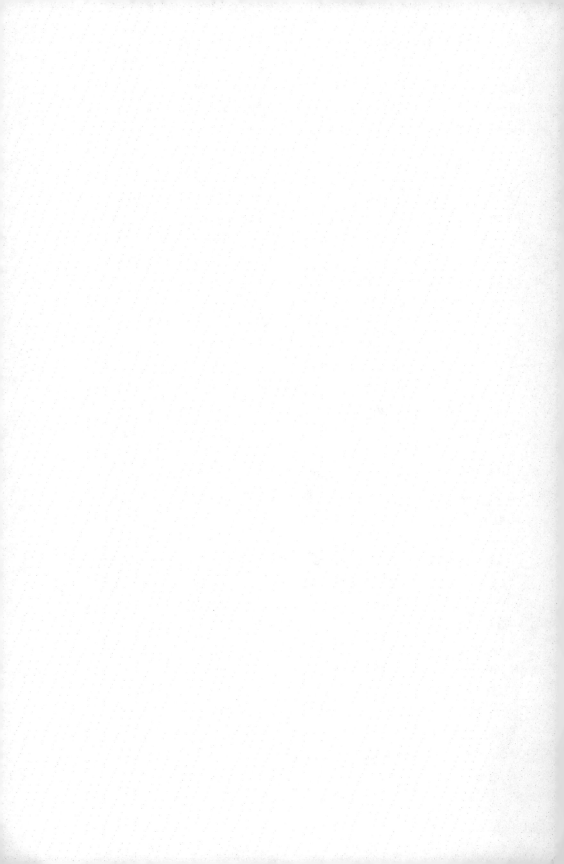

PART II

REIMA "RAY" VICTOR RATTI

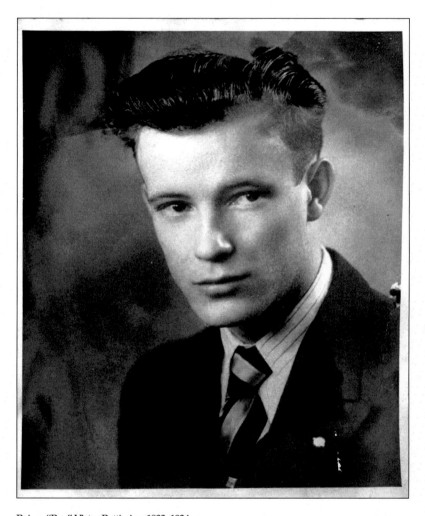

Reima "Ray" Victor Ratti, circa 1933–1934

This is a love story in some ways.

We begin with a poetic name, Reima Ratti,

a Finnish lad, who painted with his soul.

June Blythe, *Waukegan Post*, 1940

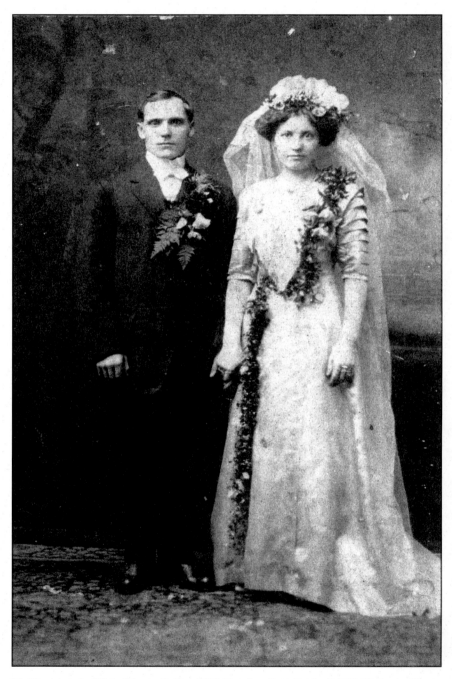

Wedding portrait of Victor Herman Ratti and Hilja Tuominen Ratti, October 7, 1911, Waukegan, Illinois.

Chapter 2

Coming of Age in Green Town

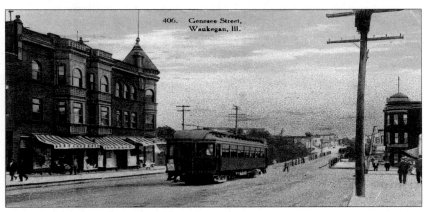

406. Genesee Street, Waukegan, Ill.

Postcard of Waukegan, Illinois, circa 1914

In the early 20th century, Waukegan, Illinois, was a place for a child to dream and create, if so inclined.

On Wednesday, July 8, 1914, an abnormally high pressure system formed over the Atlantic coast and the region of the Great Lakes. Reports for Chicago, more specifically Waukegan, Illinois, recorded a significant drop in temperature, from a high of 83 to a tolerable low of 68 degrees.

This brought in cloudy but fair weather. No doubt, it was a welcome shift in temperature for the anxious and laboring Victor Ratti family. New mother Hilja would deliver her first child that day, a son they christened Reima Victor Ratti.

Reima Ratti's immigrant parents arrived from Jurva, Finland; Victor Herman Ratti in 1906 and Hilja Tuominen in 1908. Married in Waukegan on October 7, 1911, their family was complete with the birth of their second son, Uno Melvin, in 1918,[32] who was known as Melvin.

By the summer of 1923, the American dream of home ownership became a reality for Victor and Hilja when they purchased a dwelling with bordering properties on May Street in Waukegan.[33] They settled in a community where they found camaraderie among neighbors and families who were also Finnish immigrants.

By 1920, a large portion of Waukegan's 19,229 residents were immigrants or children of immigrants. This number would grow to over 33,000 by 1930.[34]

Part of the extraordinary growth of Waukegan, 36 miles north of Chicago and 60 miles south of Milwaukee, can be attributed to industry. Other factors boosting the early 1900s' Lake County expansion were the shipping ports on Lake Michigan and the Chicago and Milwaukee Railroad; Waukegan was the midpoint on this rail line.[35]

Many Finnish immigrants, including Victor Ratti, found employment with the American Steel and Wire Company (U.S. Steel Corporation). Some of the immigrant families would Americanize their surnames; the Wainappas became Wainos and Valimaki's became Mackey. These name changes were not uncommon for Finnish immigrants at the turn of the 20th century; the Palohaka name was altered to variations of Palo-Kangas or just Kangas.[36]

Waukegan Immortalized

A poetic glimpse of Waukegan nearly 100 hundred years ago can be found in the short stories of Ray Bradbury.

A celebrated author and Waukegan native, Bradbury was, by his own admission, profoundly influenced by his early years in this remarkable locale. The genesis of his writing was literally sparked at age 11 during a Labor Day weekend carnival event in 1932.[37]

As a child, surrounded by loving parents and grandparents, Bradbury was gifted with a sensitive insight and wonder. His youthful recall would transcend descriptions of a Roaring Twenties blue-collar industrial landscape; altering the good and the bad. Bradbury, through his prose, persuasively reimagined Waukegan as "Green Town." He spun tales of an almost magical place filled with small-town adventures, simple comforts and freedom.

Not long before the 1920s bucolic Illinois reality Reima Ratti and Bradbury were born into was the Great War, the devastating war to end all wars. It was officially over with the signing of the Treaty of Versailles in 1918, though. In Europe, and especially America, the decade that followed stood as the dawning of a new and exciting age.

Picture-Perfect Hometown

This was no youthful fantasy; the belief and seeming reality of what lay ahead was an era of peace and prosperity, especially for a child of immigrants who were prospering in the Americas in the 1920s. It was a time filled with . . . pies cooling on window ledges; wet, green lawns; rope swings hanging from trees; rejuvenating sunshine; and, through open bedroom windows, the morning call of songbirds mixed with the clang of a trolley, train whistles, signaling in the distance and parades, lots of parades.[38] Walking through downtown Waukegan, one could crane his neck or, if a child, rock back on his ankles to look up to see the majestic Clock Tower. During these promising years, Ratti became a Boy Scout achieving a Second Class rank.[39]

For many families, the 1920s brought a wave of home improvements: the vacuum cleaner, washing machine, and the introduction of the home radio. This last revolutionary technology brought the world into living rooms and ushered in sounds of advertising jingles and music like "Happy Days Are Here Again."

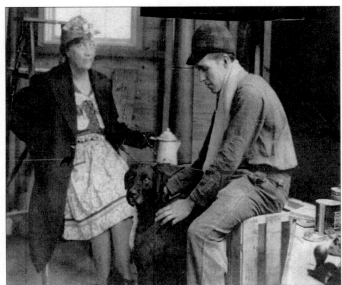

Artist friend, Roland Hellman, right, helped Reima build the May Street studio. Reima's mother,.Hilja, left, kept the coffee warm during its construction. The dog, Hilja had said, just wandered into the picture.

Add to these Waukegan vignettes the Ratti's modest May Street home. It included Hilja, with her welcoming pot of coffee and her son, with the artist's studio he would build on an adjacent lot. The studio became a gathering place for Waukegan artists coming of age during the 1930s, a decade after Ratti did. The difference was that this later era would come to be known as the Great Depression.

"She teaches numerous classes in art, and in the Annual she has a big part.

"She teaches us how to wield our pencils, To draw clever figures, and cut stencils."

FRANCES L. HIGLEY - Art
1935 Waukegan High School "W" Annual
University of Wisconsin, B.M., Chicago Art Institute,
Chicago Applied Arts School, University of California,
University of Chicago, Rhode Island School of Design.

1934 WTHS Poster Club, (L to R)
Charles A. Jickling, Advisor
and Reima Ratti, student

LA REINE McKINNEY - Art
1935 Waukegan High School "W" Annual
Alma College, University of Wisconsin,
University of Michigan, Columbia University,
University of Chicago B. of A.E.

Three of Ratti's high school teachers were instrumental in helping him cultivate his artistic talents: Frances Higley, Charles A. Jickling, and LaRaine McKinney, as shown in the Waukegan Township High School 1933–1934 yearbook.

Chapter 3
Educators Who Inspired

Just two months after the stock market crash of 1929, Ratti entered Waukegan Township High School (WTHS) with the midterm freshmen class. It was January 1930. Luck was with him. He would soon engage with a remarkable group of educators offering a well-established art program.

Beginning in 1925, years before Ratti's arrival, the "W" Art Club was formed at the Waukegan Township High School. Miss Frances Higley, a respected Waukegan native and valued yearbook adviser, would eventually become the director of the Art Department. She was assisted for the next 19 years by Miss LaRaine McKinney. Waukegan Township High School also benefitted from a Poster Club, administered by mathemetics teacher Charles A. Jickling, and an on-site printing department, which published the school annuals, publications and posters. These art educators guided and influenced generations who would struggle through the unemployable Great Depression and those who would come of age during the first and second World Wars.

Under Higley's direction in early October 1928, the regular art classes joined with the high school yearbook staff and Printing Department. Their goal was to design the finest and most attractive annual ever produced at Waukegan High School. The students met daily and chose a theme they would develop and follow through every phase of the book.

Art students designed the illustrations and then hand-carved the 50 linoleum blocks needed to print 20 full-page, color illustrations. In addition, they created 25 pen-and-ink drawings used for the cover design, background panels, title and content pages, tailpieces, etc.

REIMA RATTI

Reima Ratti, Waukegan Township High School junior yearbook photo, 1932–1933.

WAUKEGAN TOWNSHIP PUBLIC NIGHT SCHOOL
WAUKEGAN, ILLINOIS

Division of Shops, Commercial,
Home Making and Related Subjects.

RECEIPT CARD

Date _Oct 13, 1930_

Resident Deposit $3.00

Name _Ratti, Reima_

Non-Resident Fee $5.00

This is to certify that the above person has paid all necessary fees of registration for work in Waukegan Township Public Evening School for a period of one term of twenty nights. Attendance has been arranged as provided in the schedule of classes.

Term _1st_

J. W. Thalman

W.T.N.S. PRINT 316

J.m.

Superintendent

Reima registered for all available art classes offered by the Waukegan school district.

Ratti availed himself of day and evening art classes offered by the Waukegan Township public school system. In addition, he joined clubs where he found experimentation, encouragement and inspiration.[40]

During these high school years, friendships would solidify and be influenced by other aspiring student artists. One was Ted Bonnickson, who, like Ratti, was a member of the school's art clubs. For two terms, both also were enrolled in the Reserve Officers' Training Corps (ROTC) program. It was an exciting period for these young artists, who came of age during years of hardship and struggles for their families.

It was 1932, the third year of the Great Depression. Times were so dire, the Arlington Heights, Illinois, _Daily Herald_ printed a notice from its publisher, Paddock Publications . . . the paper was going to take a week off. The editors termed it a vacation . . . in reality it was

Vacation Next Week-No Paper

The Paddock Publications are going to take a vacation next week. The editors, big and little, linotype operators and all are going to take a week off. Not because they have any money to spend, but in the hopes that the week will bring to them a bit of optimism and the assurance that this is not such a bad world after all.

The business office and job printing departments, however, will be open.

The reporters are thus also given a vacation and all will return to duty August 15th, ready to make the paper bigger, better and newsier than ever. May we have the cooperation of our readers, friends who will overlook the issue that will be missed.

The editors feel that all will benefit in getting away from the customary grind of a newspaper office and return with a lot of pep that will help lick Old Man Depressions around "these diggins."

Daily Herald, August 5, 1932

an attempt to bring a respite from the oppressive news, an attempt to offer the paper's staff a chance, for time off, to "lick Ole Man Depressions around those diggings."

A longing for distraction and entertainment was ever-present. With the advent of spring, a menagerie of traveling circus shows would commence, with cities like Waukegan on the circuit tour. Local and county papers attracted readership and built excitement with promotional articles, contests and advertisements highlighting these extravaganzas.

Clyde Beatty, infamous animal trainer and star of the Habenbeck-Wallace traveling circus was featured in "Playing With Death," published in the Illinois *Decatur Herald Daily Review*, August 14, 1932, p. 9.

The *Waukegan News Sun* was filled with articles and advertising leading up to the Big Top trifecta, which descended on the city September 3, 1932. There would be parades, death-defying feats, contests and performances day and night.

Chapter 4

Come One, Come All

Ratti turned 18 in the summer of 1932, and just as he was readying to return for the second semester of his junior year, his hometown became the scene of a spectacular trifecta.

Waukegan and, more widely, Lake County is centrally located by rail and road and would see lots of activity and entertainment that summer and into Labor Day. Several carnivals and Big Top traveling circuses would pass through the town and neighboring Chicago.

The first of the extravaganzas arrived early on the morning of Saturday, August 6, 1932, when Ringling Brothers Barnum and Bailey Circus reached Chicago's Illinois Central Station.

"Traveling on four trains of double-length steel railroad cars, the giant of the super circuses brought 1,600 people, 1,000 menagerie animals, 50 elephants, 700 horses and a herd of the largest and tallest giraffes." By noon, the world's largest canvas city of 30 tents was raised, as the 800 performers and 100 internationally celebrated and beloved clowns made ready for the 2 p.m. show in Chicago's Grant Park.[41]

For the next nine days and nights, the windy city would be transfixed by high-flying, death-defying feats and great pageantry, a welcome diversion. The show's management reported its most prosperous run on the lakefront in several years . . . the big top filled almost to its 16,000 capacity at every performance."[42]

Later that same month, another carnival opened just north of Waukegan at the Illinois State Fair. The Hagenbeck-Wallace Circus was billed as the Greatest Wild Animal Circus in the World. It would bring the show to Waukegan, an exhibition promising leopards, panthers, bears and Clyde Beatty's world-famous animal act . . . a mixed group of 40 Siberian and Royal Bengal tigers . . . black mane African lions and lionesses in the huge steel presentation den."[43]

The momentum was building until Saturday, September 3, 1932—Labor Day weekend—the trifecta arrived and performed in Waukegan, home to Ratti and 12-year-old Bradbury.

The Hagenbeck-Wallace Circus, traveling by truck from Milwaukee set up tents and cages to showcase, day and night, Clyde Beatty's "Playing With Death" lion-taming act and WILNO, the human cannonball.

Competing with this menagerie of displays was the early morning arrival by train of Downie Brothers circus, featuring the "Buck Owens Wild West Ranch." It offered yet another opulent collection of performance marvels, along with a noontime street parade.

To top that, on the east side of town, the American Legion was sponsoring a three-day summer festival on the lakefront with a wrestling show and bathing beauty contest.

The day was overflowing with memorable sights, entertaining events and electrifying happenings. There were visuals to inspire the creative minds and fervor of Waukegan's receptive youth.[44]

The young artists of WTHS had no trouble finding a theme for their next high school annual—"Circus." They heralded the student body as the The Greatest Show on Earth and featured an extraordinary menagerie of art in their yearbook.

Ratti had found his artistic calling and was in his element.

Waukegan High School Poster Club, as shown in the school's 1933 yearbook, from left: Ted Bonnickson, Roland Hellman, Reima Ratti; at center, Poster Club adviser and mathematics teacher Charles A. Jickling.

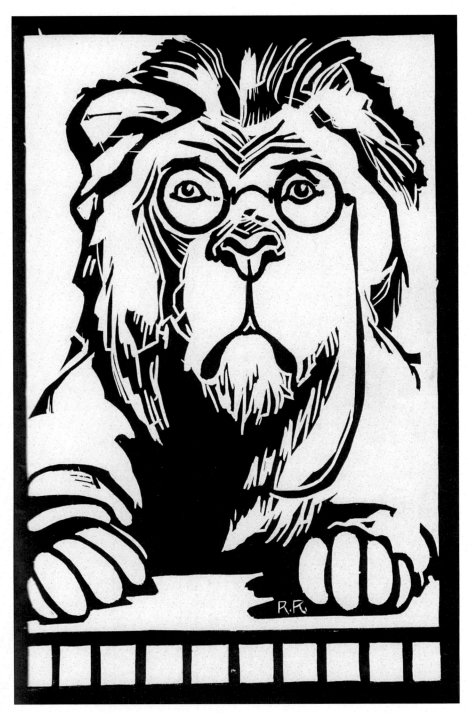

The studious black mane lion woodcut artwork created by Ratti and published in the 1933 Waukegan Township High School yearbook was likely influenced by the Labor Day circus show featuring so-called world-famous animal trainer Clyde Beatty.

Above all, try something.

Franklin Delano Roosevelt

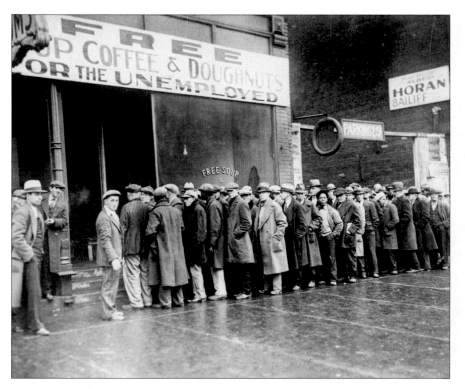

Unemployed men queued outside a Depression soup kitchen opened in Chicago by Al Capone.

Chapter 5

A New Deal

During the summer and fall of 1932, other momentous events were developing. Both the Democratic and Republican parties met in Chicago to nominate their respective candidates. Franklin Delano Roosevelt (FDR), governor of New York, was the Democratic choice on the fourth ballot. Herbert Hoover, the incumbent president, was nominated by the Republicans on their first ballot.[45]

It was now four years since the fallout of the 1929 economic collapse; there was widespread, crippling unemployment (estimated to be a staggering 24%), wages and hours were cut, workers were laid off, banks failed, homes were foreclosed and hunger was rampant. This downturn continued at a grueling pace, with painful documented images of Hoovervilles, evictions and outright begging. People were becoming more receptive to a new voice and promise for "a New Deal for the American people."[46]

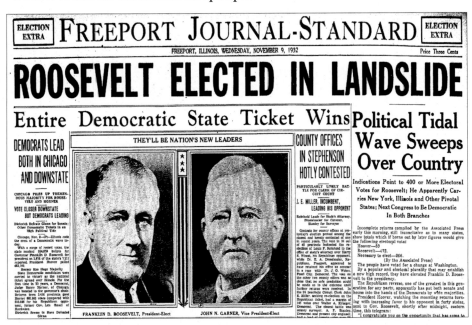

News outlets across the nation reported the landslide victory of Franklin Roosevelt and the sweep of the Democratic Party in many state elections. Headlines similar to those in the *Illinois Freeport Journal-Standard* special election edition, November 9, 1932, appeared on the front pages of many publications. The nation was ready for Roosevelt's promised New Deal.

The November 8, 1932 presidential election brought decisive victory and historic change in leadership. Illinois results showed Roosevelt received 1,882,304 votes as opposed to Hoover's 1,432,756.[47]

That following evening, President-elect Roosevelt took to the radio and addressed the nation. He thanked them for their overwhelming vote of confidence, a decree he believed had expressed . . .

> . . . *that the masses of the people of this nation firmly believe that there is a great and actual possibility in an orderly recovery, through a well-conceived and actively directed plan of action. Such a plan has been presented to you and you have expressed approval of it . . . It shows that there is in the nation unbounded confidence in the future of sound agriculture and honorable industry. This clear mandate shall not be forgotten. I pledge you this, and I invite your help, the help of all of you, in the happy task of restoration."*[48]

Four months later, on March 4, 1933, Roosevelt was inaugurated the 32nd president of the United States. He was empowered by the confidence and vote of the American people and wasted little time communicating his plans via the latest in technology—the radio. These airings became known as FDR's Fireside Chats, and many people felt he was speaking directly to them.

Radios provided reassurance and created a new sense of immediacy, of being in the moment when an event was occurring. Broadcasting in "real" time was a novel idea and a powerful one.[49]

On the 1930 U.S. federal census, there was a curious question under the home data category. A line item asked if the household had a "radio set." Many residents on May Street in Waukegan, including the Ratti family, answered "yes," there was a radio in their home.

Perhaps Ratti, not yet of voting age, tuned into the real-time transmissions and listened to the president's reassuring messages.

In FDR's second Fireside Chat on May 7, 1933, he spoke of a new conservation movement, the Civilian Conservation Corps (CCC). A work program, it would send young men with dependents "into forestry and flood prevention work."

The president stressed that no military training was involved and he praised the program . . . "we are conserving not only our natural resources but also our human resources."[50]

How much thought the young Ratti, who was still in high school, gave to the CCC or FDR's "happy task of restoration" would not become relevant until two years later, in 1935.

As FDR was promoting his New Deal to a nation in economic crisis, Waukegen residents were living the stresses on a daily basis. The city had the highest tax rate in its history, yet its income had declined. Land and home values had plummeted, which negatively affected the city's income from property taxes. Additionally, local government revenue had further dropped due to defaults, as many homeowners were unable to pay their bills. These compounded revenue losses forced Waukegan to cut operating expenses.

The high school was mandated to shorten the school year by three weeks; it ended in May 1933 rather than June. This cutting of services was also repeated in other Chicago area school districts.[51]

Putting food on the table while keeping up with a mortgage and other obligations was a hardship for the Ratti family. Property taxes were among the debts the family were unable to pay.

Though an earlier Waukegan yearbook briefly referred to the 1929 crash, the 1933 high school annual, which Reima had a part in creating, made no mention of the looming unemployment or economic struggle facing the graduating class. Instead, wishes for a bright future were printed on a custom-designed calendar.

Pasted to a back page was a foldout insert ironically depicting dollar bills. When opened, the insert revealed a chronological listing of the year's milestones and events. The final entry included optimistic, pseudo prose anticipating happy days ahead:

> *May 19 . . . School out. Now for a long summer vacation — sleep till 10, swim, fish and all that goes for a keen time.*[52]

For Ratti, who had one semester remaining in his senior year, the adjective *keen* would take on a profoundly different and painful meaning that summer. Ratti's father, Victor, was gravely ill.

REIMA RATTI
"Ray"
Annual Art 3, 4 ; Jr. Life Saving 2 ; Military 2, 3 ; Poster Club 4 ; Sr. Life Saving 3.

Ratti's Waukegan Township High School senior portrait, published in the school's 1934 yearbook, shows pins on his lapel and tie. They may be the awards given by the Art Department to students of outstanding merit.

Chapter 6

A Sad Day In Green Town

*My poor, dear Grandma (Hilja Ratti).
She, most of the time, looked sad. And
losing her love of her life so young . . .
she was loving and kind, never had a bad
word toward anyone, never raised her
voice . . . sang Saturday (and) Sunday
mornings like a bird . . . did whatever to
help Reima with his work studio, but sad
eyes.*"[53]

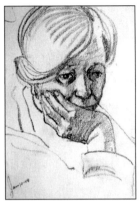

Sketch of Hilja Ratti believed to
be by her son.

Cheryl Rae (Ratti) Coggins

Ratti's father, Victor, held his last full-time job in 1928 as a "rod
mill" (operator) for the American Steel and Wire Mill (AM). It was a
stressful and physically demanding job. Victor had worked at the mill
since his arrival in Waukegan 27 years earlier. After leaving the mill,
he found work as an independent truck driver.[54]

The elder Ratti was ailing during 1932, the family was struggling
financially, and this appears to be when they began defaulting on
their May Street property taxes.[55]

Dr. Harry J. Toomajan, a Waukegan physician whose office was
less than a quarter mile from the Ratti home, had been treating Victor
for the past year. His diagnostic findings were an abdominal form
of tuberculous, an agonizing illness before the days of the antibiotic
streptomycin. Victor was receiving continuous care from Dr.
Toomajan, when his condition worsened on June 20,1933.

Within a week, on the afternoon of July 27, 1933, the 42-year-old
husband and father died at the May Street home. Four days later, he
was buried at Waukegan's Oakwood Cemetery. It was a sad day in
Green Town.

Chicago Tribune, October 8, 1933, p. 82.

Ratti returned to WTHS in September to complete the last semester of his senior year, majoring in English and art. It would be a busy six months. He was elected president of the Poster Club, worked with the yearbook staff and received a 12-week scholarship to train every Saturday at the Chicago Academy of Fine Arts.

Ratti graduated WTHS with the January 1934 midterm class. These graduates ended their schooling just as the world's economy hit rock bottom. It was one of the worst years of the Great Depression.

The Rattis had close family in Wyoming. Hilja's older brother, Iver Hiibacka, had immigrated to the United States in 1901,

Sketch by Ratti titled *Frontier Wyo.*

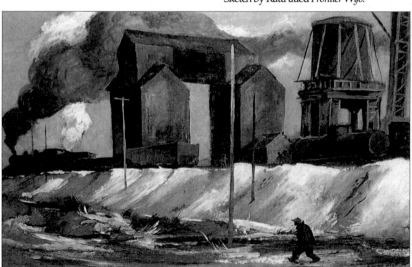

Painting by Ratti was given to his Uncle Iver Hiibacka.

seven years before Hilja left Finland. By 1910, he was settled in Rock Springs, self-employed as a tailor and newly married.

Iver became active with local Finnish committees and by 1934 was well-established as the owner of Hiibacka and Company, a custom tailoring, cleaning and repair business well-situated in downtown Rock Springs.[56]

After high school, Ratti took a trip to Wyoming with friends, sketching the rivers and mountains, the mines and industries of the West. The Waukegan buddies Ratti may have traveled with were Rolland Hellman and Ted Bonnickson.[57]

When they returned to Waukegan, Ratti worked at a filling station, but there was no meaningful work for him or other recent high school graduates. In September 1934, Bonnickson applied to the Lake County Relief Committee at 325 West Washington Street, Waukegan. The only work available for a young high school graduate was with the first and most successful of FDR's New Deal programs, the CCC.

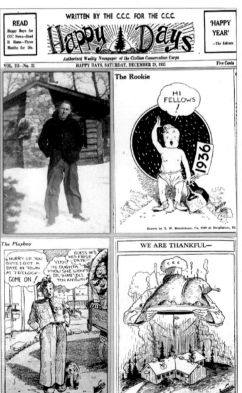

Ted enrolled for six months of pick and shovel work with the CCC and was assigned to a camp less than 30 miles south, in Des Plaines, Illinois.

Bonnickson, an intelligent and personable young man, possessed tremendous artistic talent, especially for humorous illustrations. Little could he or Ratti know how his two-year CCC enrollment would afford him the opportunity to move west with his CCC company. These transfers would eventually position Bonnickson near Los Angeles. There, he applied for a job in the newly emerging animation industry.

Composite image: upper left, Ted Bonnickson, CCC artist at camp, date unknown; three illustrations by Bonnickson published in the *Happy Days* camp newspaper.

Ratti was pleased when he learned his Waukegan high school friend had left the CCC after signing a five-year artist's contract with Walt Disney Studios.[58]

It wasn't long after Bonnickson's departure from Waukegan that Ratti took a serious look at applying for the same reforestation work. The CCC was a labor force, but it was work that would provide a monthly allotment to his mother.

When the next six-month CCC enrollment period began, in the spring of 1935, Ratti applied. The Lake County Emergency Relief Committee was given a quota by the Labor Department for 50 new unemployed, single male applicants between ages 18 and 25.

On his April 25, 1935 application, Ratti admitted to never being employed but listed his occupation as "sign painter." Two days later, on a rainy Saturday, Ratti and about 50 other boys from Waukegan weren't sent into the woods. They were assigned to the rock pile at CCC Camp Estabrook, 60 miles north, in Milwaukee, Wisconsin. Each was assigned the status of "Junior Laborer."[59]

STATE CCC QUOTA NOW SET AT 3,505

WASHINGTON, April 9 (P)— Wisconsin's quota of replacements in the Civilian Conservation corps to be selected immediately for enlistment between April 15 and May 1 was set today at 3,505.

Rhinelander Daily News, April 9, 1935, p.1.

In Milwaukee, each received the obligatory physical examination. Ratti was recorded in good health, 5 feet, 8 1/2 inches tall, 149 pounds, light complexion and brown hair. His brown eyes, upon testing, were found to have moderate visual impairment, which was corrected by glasses. New recruits were inoculated for typhoid and smallpox, given clothing, and shoes, and then assigned to one of the Camp Estabrook barracks.

Ratti was a rookie but one with the eye of an experienced artist. Within months, he was sketching his new home, surroundings, work project and the mannerisms of his fellow enrollees.

Hilja, his mother, continued to struggle with mortgage payments and mounting debt, as the delinquent property taxes continued to accrue.

[CCC Individual Record form image]

JUNIOR ARTIST

INDIVIDUAL RECORD—CIVILIAN CONSERVATION CORPS

GENERAL INFORMATION

(1) Name: Ratti, Reino CC6-146253 (2) Address: 1012 May St., Waukegan, Ill.

(3) Date of birth: July 8, 1914 (4) Birthplace: Waukegan, Ill.

(5) Nearest relative: Mrs. Hilja Ratti (6) Unemployed since: Never

1012 May St., Waukegan, Ill.

(7) Citizenship: Native born (8) Color: White

(9) Were you previously a member of the Civilian Conservation Corps? No

OATH OF ENROLLMENT

I, Reino Ratti CC6-146253

(Signature) Reino Ratti

(Place) Milwaukee, Wisconsin

Sworn to and subscribed before me this 27th day of April nineteen hundred and thirty five

O. B. Robinson, 1st Lt.

CCC employment records for Ratti indicate his mother, Hilja, was the designated dependent to receive his $23 monthly allotment.

Ratti would designate her as his nearest dependent, meaning she received his $23 monthly allotment.

Younger brother, Melvin, was still in high school and working hard making pennies on paper deliveries for the *Waukegan News-Sun*; the publication would acknowledge Melvin's efforts in a 1934 subscription contest.[60]

Sketch of a newspaper delivery boy.

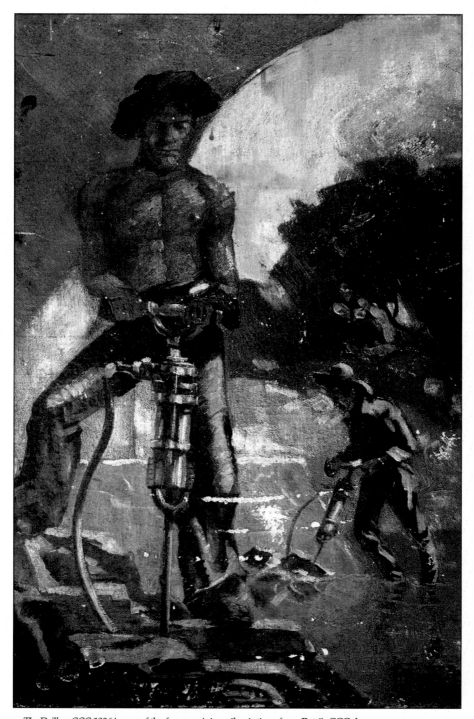

The Drillers CCC 1936 is one of the few surviving oil paintings from Ratti's CCC days.

Chapter 7

Milwaukee Rock Pile

The hard work of CCC Company 1699 at Estabrook Park began November 13, 1934, when it moved from its Richmond Center location to begin flood-control work on the Milwaukee River.

One of the largest CCC projects in Milwaukee involved straightening the Milwaukee River. The waterway made a complete S turn as it coursed through Lincoln and Estabrook Parks, causing ice jams and floods every spring. The first stage of the CCC project was changing the course of the ancient river. This entailed months of drilling and blasting, using hundreds of pounds of dynamite and thousands of labor-intensive man hours to haul away the 6,000-by-200-foot rock ledge. Deepening and unbending the natural channel was an enormous and aggressive government undertaking.[61]

The massive quantities of rock and limestone removed were crushed on-site and used for embankments and roads in Estabrook, Lincoln and other Milwaukee parks. In addition, it was distributed to "construction projects in the county for drives, walks, parking stations and tennis courts."[62]

C.C.C., RVR, Estabrook Park stone crusher building, August 6, 1935.

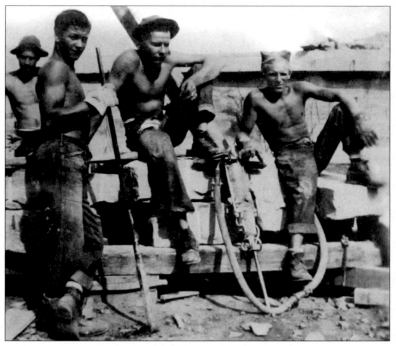

Drillers of CCC Company 1699.

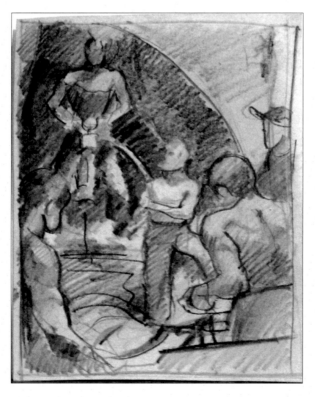

Sketch of CCC driller and workers.

Heavy equipment supplemented CCC manpower in removing boulders from the Milwaukee River.

Some of the crushed stone was even used for a decorative waterfall sculpture within CCC Camp Estabrook. It was a point of pride for the camp designer, until the inaugural day when the water was turned on, resulting in an embarrassing flood that collapsed the ornamental structure.[63]

The next stage of work programs were plans, which tasked the CCC boys with an even bigger project. They were to build a dam across a section of the Milwaukee River. The work began in the early months of 1935 with the consrtruction of a dike in the Milwaukee River.

> "Boys at Estabrook park cleaned about 100,000 cubic
> yards of rock out of the bed of the Milwaukee river
> for three-fourths of a mile and are now completing a
> $65,000 dam with flood gates that is expected to lessen
> flood damage . . . Rock from the river . . . has been
> crushed and used for roads (embankments) and in the
> dam."[64]

In the weeks before Ratti arrived, there was an ice jam on the river from a March freeze. The eight-foot-high dike, built of cracked stone and dirt, was in danger of failing. The boys of Company 1699 rose to the challenge, dynamiting and chipping away at the frozen blockade.

"The turgid river was lapping at the top of the dike . . . Five dynamite charges were set off through the night . . . Workers, equipped with pickaxes and poles worked though the semidarkness, standing on ice cakes and hacking at them to break up the ice and sent them downstream."[65]

It was this group of experienced and hardened CCC laborers Ratti joined in the spring of 1935, fellow CCC enrollees he would depict in his drawings, paintings and sculpture.

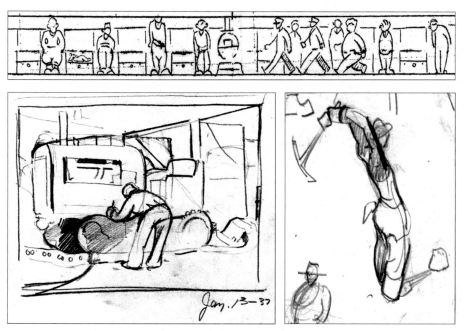

Sketches of CCC life and the work project by Ratti: (top) barracks inspection, published in Skipper's Scandal, March 1937; (middle left) truck maintenance, Jan. 13, 1937; (middle right) working on the rock pile; (bottom) No. 4 of CCC boys loading a truck, which became part of the final composition for the oil painting, On the Grade (facing page), featured in the Milwaukee Journal.

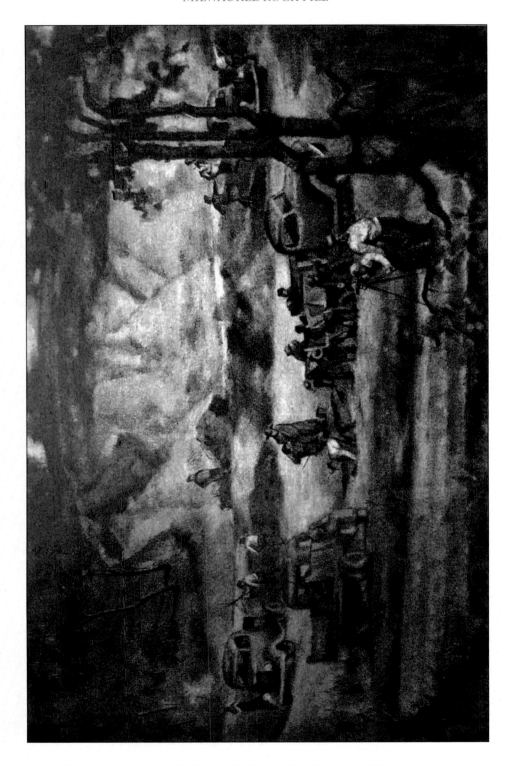

On The Grade, oil painting by Reima Victor Ratti, *Milwaukee Journal,* January 19, 1936.

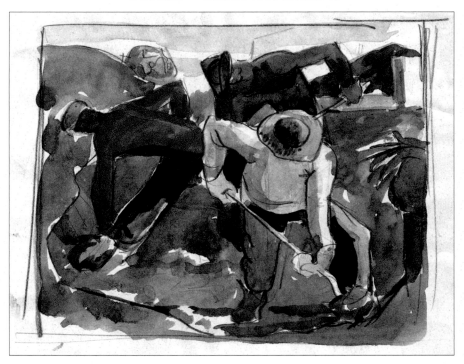

Many of Ratti's sketches and watercolors depicted work scenes from different angles and perspectives. The bottom 2017 photograph records the Estabrook Park Dam The flood gates no longer were reliable; they were left open for fear they would fail and cause extensive flooding of the Milwaukee River. Several months later, in the summer of 2018, the dam built by the CCC in the 1930s was demolished.

Chapter 8

Welcome Rookies

With the arrival of the Waukegan replacements, the company strength was recorded as "199 white and 2 colored men"; 142 from Illinois and 59 from Wisconsin. It was a full roster.

This would be the only enrollment period in which the company would be at full strength and integrated. The average enrollment strength, for the next two years, was 145 junior enrollees, all white.[66]

Within days of their arrival, the boys from Waukegan were welcomed in the camp newspaper, the *Skipper's Scandal*. The issue was dedicated to the rookies:

Skipper's Scandal, February 1937, p. 2.

> *You are 'Green' and we realize it but don't become discouraged. Everything seems to be against you now but make the best of it. We were once "'Rookies'" ourselves. The veterans will assist you in becoming acquainted with the daily routine of camp life.*[67]

For their first two weeks, all new recruits were confined to camp. The stated joke was the rookies were pleased with the issue of their new toilet kits, and that a few really needed them. As new enrollees, they were encouraged to participate in camp activities, visit the library and to try out for the baseball, softball and volleyball teams. If they failed to make a team then they could "boast" for those who did. Ratti's name is not found on any of the athletic rosters.

This Waukegan group had a median age of 21 and, collectively, received 10.2 years of schooling. If they "could take it," they would become a part of a group known as the Crushers. A proud CCC company, whose chief aim was to be the best camp in the district, much was expected of these new rookies.

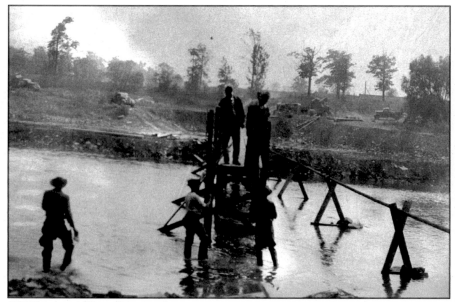

CCC Company 1699 enrollees at work..

Enrollees who were part of the drilling crews were proud of their compressor, "which is neatly mounted on a two-and-one-half-ton Dodge truck chassis."[68]

Ratti remained with Company 1699 for 51 months, until July 18, 1937. It was a productive, maturing period in the young artist's life.

Ratti created multiple sketches from different angles and perspectives of the CCC work projects, 1935.

Dynamite Training

"Dynamite class opened with a boom and a bang Tuesday evening, May 6, 1935."[69] Several enrollees signed up for instruction that would prepare them for the state examination to become licensed blasters; dynamite was widely used for this river alteration project and the CCC authorities took all forms of safety measures seriously.

The dynamite crew of 1935 consisted of five men divided into two shifts, 6 a.m. to noon and noon to 6 p.m. Those assigned to the rock crusher formed two crews of 38, working two six-hour shifts. Each shift crushed between 60 and 100 yards of rock per day. The balance of the CCC Company 1699 labor force not assigned to camp or kitchen duties belonged to the regular shift. They worked 8 a.m. to 4 p.m. spreading stone on the roads around the project.[70]

Art Training, Too

While in Milwaukee, Ratti continued with his art education by enrolling in the Milwaukee Art Institute (MAI), where he studied with Robert Franz von Neumann (1888 [Germany]–1976[Wisconsin]).

"Much like the American Regionalist work of the '30s and '40s, Von Neumann drawings, paintings, pastels, etchings, mezzotints and lithographs illustrated the virtues of the common man." Von Neumann was also on the art staff of the *Milwaukee Journal*.[71] Ratti would be as versatile as his teacher and work in several of these mediums including mural painting.

On at least two occasions in the spring of 1936 Ratti discussed "openings in art and openings for training at city museum" with the CCC camp educational adviser.[72]

This training was part of the Works Progress Administration (WPA) projects at the Milwaukee Public Museum (MPM.), "a series of WPA projects which generally referred to more broadly as the Museum Project."[73] The goal was the creation of an Oriental Hall "where replicas of Buddhas and other Chinese forms and paintings will be used in construction of a Chinese room."[74]

Ratti participated in creating murals depicting *Five Steps In the Cutting of Jade*.[75]

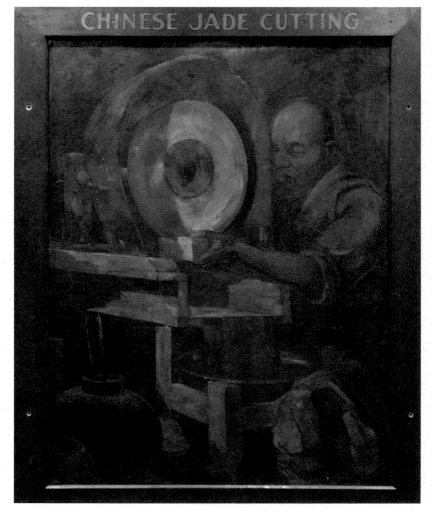

In 1937, Ratti enrolled, for training purposes, with a Milwaukee Public Museum project funded by the WPA. Among the murals he created was *Chinese Jade Cutting*.

Although Ratti,was a regular CCC enrollee, he registered with the MPM Department of Anthropology, Division of Ethnology, and used his May Street, Waukegan, address. The official MPM records reflect "Reima V. Ratti was working . . . for what he could learn. He was paid no wages."[76]

Ratti received no compensation for this WPA work; it would have been a violation of government policy to be employed by more than one New Deal program at the same time. This means CCC laborer Ratti, who was not yet an official CCC artist, was not a WPA artist and never was. Ratti presumably flew under the radar by taking

advantage of an art program funded by the WPA while enrolled in the CCC. Both he and the MPM benefitted from the work he produced during this museum art training. The MPM covered the cost of training, art supplies and framing.

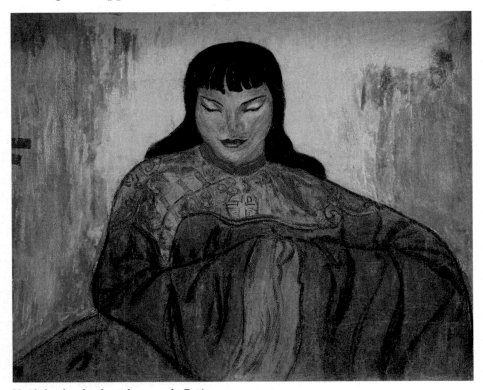

Untitled and undated pastel on paper by Ratti,

Untitled sketch.,

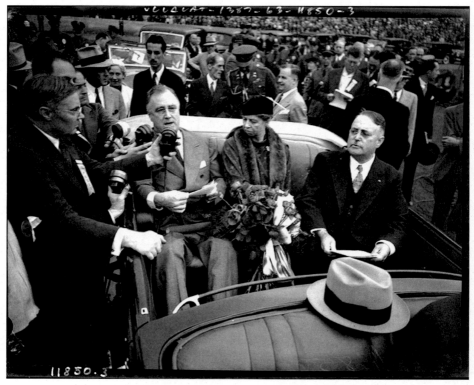

The motorcade accompanying President Roosevelt and Mrs. Eleanor Roosevelt on their driving tour of Los Angeles can be seen in the background of this press photograph. One stop the parade of cars made on October 1, 1935 was at a CCC camp in Griffith Park. There, the president unveiled the 10–foot-high concrete *Spirit of the CCC* statue created by sculptor Uno John Palo-Kangas.

Chapter 9

President Comes To Town

In May 1935, there was a change of educational advisers at Camp Estabrook. Because of this transfer, the educational program seemed adversely affected. The weekly newspaper, *Skipper's Scandal*, was abandoned, the camp had lost a creative, journalistic voice.

There were, of course, the local Milwaukee publications and the nationally sanctioned *Happy Days* available in the camp library. No doubt, Ratti saw the many submissions of art published in *Happy Days* by Ted Bonnickson, his high school buddy, but there was another article featured in this unofficial national CCC newspaper that may have caught Ratti's eye and imagination.

In September 1935, President Roosevelt announced that he would begin a trip to the Pacific coast.

> *"Mr. Roosevelt told newspapermen he had only two definite stops in mind so far—at Boulder Canyon dam in the Colorado river and at the California-Pacific Exposition in San Diego. He said it was also very probable he would attend a luncheon in Los Angeles."* [77]

This luncheon expanded into a power-packed, three-and-a half hour driving tour of Los Angeles, with several publicity stops. One of the photo opportunities was a brief visit to a Griffith Park CCC camp to unveil a newly completed statue honoring the CCC worker.

Occupying the Griffith Park CCC camp was Company 1917, a group of seasoned World War I veterans. They were proud of their accomplishments in the "war to end all wars" and their current improvement projects at this Los Angeles park. It was an honor to have a 10-foot memorial in the center of their camp, whose likeness depicted what they called the *Spirit of the CCC*.

The back story for this concrete memorial was something Ratti may have never known. The management and funding for the art project, which approved the sculpture, was administered by the County of Los Angeles Relief Commission. In early 1935, Finnish sculptor Uno

John Palo-Kangas was among a few struggling artists who found work with this locally sponsored government art program. The title he gave his creation, *Conservation of Man and Nature,* had been changed to the *Spirit of the CCC* by the time the president came to town.

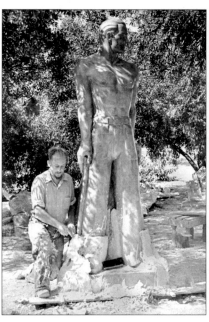

Uno John Palo-Kangas titled his sculpture *Conservation of Man and Nature.* It was changed to *Spirit of the CCC.*

The timing was tight for this presidential visit, 10 to 15 minutes was allotted. FDR, who remained in the car, leaned out the open window and pulled a cord attached to a covering over the statue. Once the concrete monument was revealed, he made the briefest of speeches. "I am glad to be here and take part in the dedication of this great statue. It is good to see you all. You are doing a splendid piece of work."[78]

The dedication of the Griffith Park *Spirit of the CCC* was front-page news in *Happy Days*, found in every CCC camp library. It is

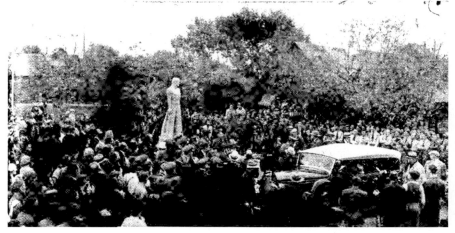

FEATURES HAPPY DAYS, SATURDAY, OCTOBER 12, 1935

With the President in California

Happy Days, October 12, 1935.

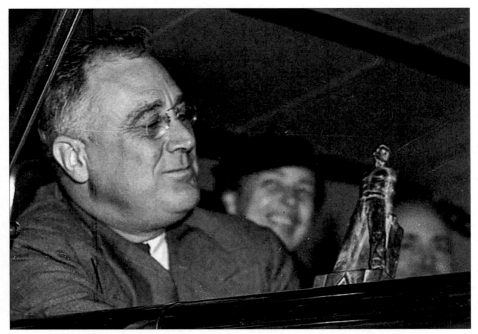

After unveiling the Griffith Park CCC monument October 1, 1935, President Roosevelt and First Lady Eleanor Roosevelt admire a gift from the Griffith Park CCC commander, a miniature of the *Spirit of the CCC* by Uno John Palo-Kangas.

reasonable to assume that Ratti saw and may have been inspired by a miniature version of the sculpture given to the President.

A Familiar Likeness

The image of a shirtless, muscular CCC boy is one Ratti and many other CCC members could easily relate to, and it reoccurs in much of Ratti's CCC art.

Within five months of FDR's unveiling of the *Spirit of the CCC*, Ratti submitted applications to the U.S. Copyright Office in Washington, D.C., for a figure of his own design. He titled his sculpture *Days Work Done—C.C.C.*

It was a heartfelt depiction of a regular CCC boy, proud and

Reima Victor Ratti self-portrait, undated.

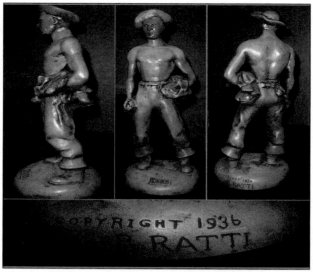

Days Work Done—CCC statue, with a closeup of the Ratti copyright on the back.

dignified at the end of a hard day of manual labor. The shirtless, muscular figure holds a crumpled jacket under one arm and work gloves or goggles in the opposite hand. The depiction had a familar stance that would be relevant and recognizable to CCC alumni five decades later.

Felonious Act On the Heels of FDR Visit

On the evening of the day President Roosevelt unveiled the Griffith Park *Spirit of the CCC* monument, a significant crime was committed in Milwaukee that would prove terrifying for the city and would have an effect on Camp Estabrook in the weeks to come.

In late October 1935, Reima sketched fellow CCC enrollees playing cards in the barracks.
Days later, the peace in Milwaukee would be shattered and Camp Estabrook would be implicated.

Chapter 10

Eight Days of Terror in Milwaukee

The CCC's fifth enrollment period began October 1, 1935. Ratti, who had been with the Milwaukee Estabrook Park CCC camp since April, signed on for another six-month tour.

The new enrollment period began with a startling discovery. Sometime during the evening of October 1 and the early morning hours of October 2, a large supply of dynamite was stolen from the park's magazine. When the CCC boys showed up for work in the morning, they discovered the door to the magazine had been pried open and 150 dynamite sticks, along with detonators and wire fuses, were missing.

For safety reasons, these dynamite magazines were well inventoried and housed a distance from the camp living quarters. It was the policy of the camp to have two guards, trusted CCC boys, patrol the worksite, buildings and grounds after the day crew left. They worked in two night shifts, 6 p.m. to midnight and midnight to 6 a.m. The evening of the theft, there was also a night crew of six men working up river several hundred feet, preparing holes for the next day's blasting.

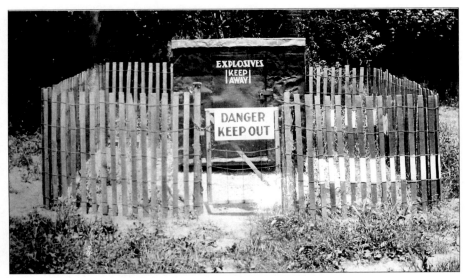

The Estabrook Park, Milwaukee, CCC camp, circa 1934, dynamite magazine prior to the theft was fenced in and well-identified. Afterward, further measures were taken to make the dynamite storage more secure.

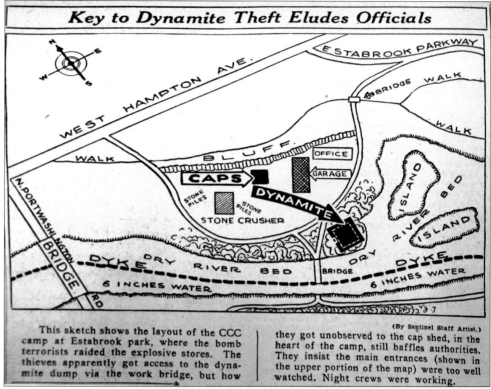

Key to Dynamite Theft Eludes Officials

This sketch shows the layout of the CCC camp at Estabrook park, where the bomb terrorists raided the explosive stores. The thieves apparently got access to the dynamite dump via the work bridge, but how they got unobserved to the cap shed, in the heart of the camp, still baffles authorities. They insist the main entrances (shown in the upper portion of the map) were too well watched. Night crews were working.

(By Sentinel Staff Artist.)

Milwaukee Sentinel, November, 6, 1935, p. 3.

The theft, despite all this activity would later puzzle investigators—there was only one dirt road leading to the dynamite magazine, and it passed by the workers and project office. How could someone, under cover of darkness, jimmy the heavy door of the magazine, abscond with three boxes of dynamite, each weighing over 50 pounds, along with the caps and fuses? It was assumed a motor vehicle would be necessary to haul it away . . . no easy matter without arousing the slightest suspicion. No amount of inquiries would ever answer these questions.[79]

Within four weeks of this burglary, the "first of the city's five mystery bombings occurring on Saturday night, October 26 at the Shorewood Village Hall."[80] The explosion, caused by a stick of dynamite placed in a drainpipe, ripped a hole in the building's foundation.[81] The force of the blast was felt at Estabrook Park, approximately two miles away.[82]

The next evening, two bank branches were blasted with coinciding false fire alarms pulled across the city. Three days later, two police stations were targeted. Those explosions created extensive damage but no injuries. Adding to this madness was the discovery that a squad

car was missing from the West Milwaukee Police Department.

After the theft, changes were made to the dynamite storage. "The guard was increased to four men under a foreman who were posted from 6 p.m. to 6 a.m. in addition to a big black dog." A concealed lock was installed, which was "supplemented by a large iron bar bolted into concrete . . . floodlights were added . . . and the guards are equipped with whistles to call for help."[83]

The city was on edge, though. Daily front-page

CCC Dynamite Raid Baffles Investigators

How and by whom was the dynamite theft from the CCC camp at Estabrook park contrived a month ago?

Police and camp authorities yesterday were puzzling over this among unsolved mysteries in connection with the "reign of terror" climaxed by explosion of the bombers' cache.

Police continued to check work crews formerly stationed nearby and trace CCC members who are AWOL.

Evidence disclosed by Sunday's blast does not explain the dynamite theft. On the other hand, circumstances of the theft bolster the theory that the two lads blown up were not the only members of the gang.

DELVE INTO PROBLEMS.

Some of the problems confronting police are:

How did the thieves know the geography of the camp so intimately?

How did they manage to steal dynamite and caps from opposite sides of the camp without being observed by watchmen or the all-night work crew on duty Oct. 3?

Could only two men have carried away the loot?

Has the bomb gang exhausted its supply of explosive, or could the unexploded dynamite found Sunday have been obtained elsewhere?

The first question may be partially answered by yesterday's discovery that Hugh Rutkowski, one of the dead bombers, frequently

swam in the river near the camp and perhaps watched the blasting operations. Park visitors and fishermen, unless acting suspiciously, were allowed to stroll through the camp unmolested.

The Estabrook camp is at the extreme north end of the park, inside a bend of the Milwaukee river. A roadway leads down over the bluff into the camp at one end and out the other. Thick willow trees and shrubs line the shore.

IN MIDST OF CAMP.

The cap shed, which the thieves looted, is in the midst of the camp. On the opposite bank a temporary crushed stone road winds south to W. Capitol drive, a mile away.

On the night of the theft CCC workers were busy on a dyke in the river channel.

Watchmen patroling the camp passed the dynamite dump every 20 minutes. Trucks crossing the bridge threw headlights on it. Yet the lock was jimmied and three 50-pound cases of dynamite were removed. At the same time fuse caps were taken from the cap shed in the heart of the camp.

WILLOWS AS COVER.

Camp authorities are convinced no automobile could have entered by the camp road unobserved. Access must have been from the far

No amount of investigation could resolve hows and whys of the crimes. *Milwaukee Sentinel*, November, 6, 1935, p. 3

news reports only heightened the tensions. Police and the G men (government men) who descended on Milwaukee were stumped.

"All three bombings are the work of one and the same crew, and the dynamite came from one source," said Deputy Police Inspector Joseph Drewniak, who believed the explosions were set off by cranks or malcontents.[84]

That source was identified as the Estabrook Park CCC dynamite magazine.

Lacking clues and looking for answers, a dragnet was conducted by outraged police. Forty-three suspects were dragged in, questioned and released. "*Wisconsin News*, a Hearst Newspaper, offered a reward totaling $5,000 for arrest, indictment and conviction of the bombers."[85]

Little did investigators know the mastermind responsible for the mayhem was also devouring these newspaper reports and was privy to police movements because he was in possession of the missing squad car's police radio.[86]

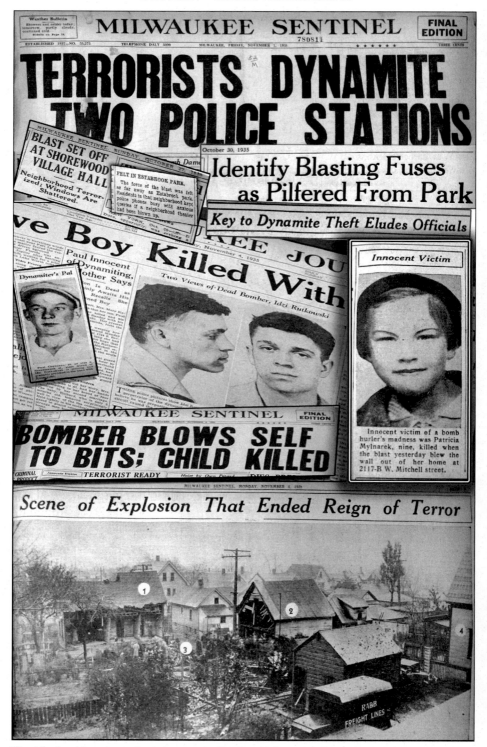

The eight days of terror were front-page news in the *Milwaukee Sentinel* and *Milwaukee Sun News* in addition to national papers.

The Mastermind

CCC Special Investigator William P. Hannon was called in by CCC authorities in Washington, D.C., to investigate.

His report found that the Milwaukee County Department of Outdoor Relief certified eligible young men for the CCC, opening up enrollment every four months.[87] The previous year, after the CCC opened the Estabrook Park camp, 20-year-old Milwaukee native Hugh Isador "Idzy" Rutkowski made an application with the county relief board to join.

Rutkowski (May 31, 1915–November 3, 1935) was born to hardworking Polish immigrant parents. A graduate of St. Vincent Academy and Boys Technical High School, he was an automobile mechanic by trade but had not been employed since April 1935.

By age 16, he'd had numerous run-ins with the law, encounters that developed into a deep hatred for those in authority, especially the police.

Rutkowski's CCC application, dated October 15, 1934, listed "Gile" Rutkowski, 2232 West Mitchell Street, Milwaukee, and his mother, Anastasia, as emergency contacts. His relief status was approved and, pending a physical exam, was tentatively enrolled with CCC Company 1697 of Coon Valley, Wisconsin, several hundred miles west of Milwaukee. After a physical exam, Rutowski was rejected. The reasons given were "numerous missing and decayed teeth, and markedly relaxed inguinal rings"[88] (meaning an increased risk of hernia). A CCC applicant was required to have at least three serviceable and natural masticating teeth.[89] Later, a vague report found in the Milwaukee County Relief headquarters listed the reason for refusal as "father, an alien." This rejection, police believed, may have been the motive, a year later, for the dynamite theft from the Estabrook Park CCC camp.[90]

It was theorized that Rutkowski and accomplice Paul Chavanek, 19, became familiar with the comings and goings of the Estabrook Park CCC camp, the work crew and guard schedules.[91]

Deadly Results

During the Milwaukee bombings and investigation, numerous news reports contained bulletins, theories and interviews with authorities and witnesses. One even contained words of caution from the CCC camp: "Engineers say it is no amateur's job to properly set a cap in a stick of dynamite and attach the fuse . . . The fuse system is seldom used, being too dangerous."[92]

On Sunday afternoon, November 3, 1935, the amateur bomb maker, whose threats had escalated to more deadly devices left in larger public locations, was assembling a super bomb, an explosive timed to go off. One possible target might have been a local theater, possibly later that day.

Mercifully, things did not go according to plan. Shortly before 3 p.m., there was a devastating explosion behind 2121 W. Mitchell Street. The South Side Polish district of Milwaukee was rocked. The blast, heard up to two miles away, blew out the fronts of buildings, shattered windows, and more than 40 buildings for blocks in all directions, suffered fallen plaster and other interior damage.[93]

Undated sketch by Ratti.

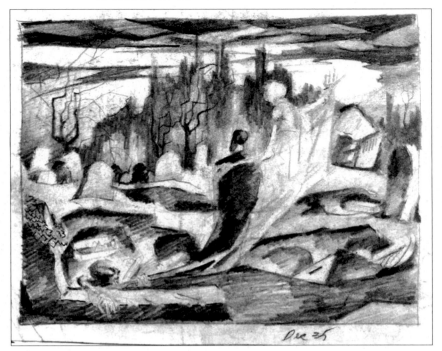

Ratti's sketches, made weeks after the 1935 dynamite burglary and bombing tragedy, depict a dark and foreboding cemetery scene. The Grim Reaper embraces and distracts a seemingly naïve young man, unaware of a menacing corpse, whose skeletal grasp drags the unsuspecting down toward the underworld.

In the aftermath, police theorized a short circuit in the wiring set off the massive explosion. Detectives scoured the debris of the leveled garage, uncovering a grisly scene. Along with a mangled clock and wires were body parts believed to belong to Rutkowski and Chavanek. Further evidence was discovered.

> *"Two boxes of dynamite, by a strange quirk, were found at the scene of the explosion. It was part of the loot stolen . . . from the October 2 Estabrook CCC camp . . . each box contained 50 one-pound sticks . . . in each of the previous dynamiting's . . . police believe only one stick was used . . . it's estimated 40 sticks of dynamite went off in Sunday's blast."*[94]

The most tragic loss of this rage was the death of Patricia Mylnarek, age 9. The Mylnarek home was adjacent to the shed Rutkowski used, and part of the dwelling collapsed in the blast, killing Patricia. The so-called super bomb injured 11 other people, some seriously. Milwaukee's eight days of terror had come to an end.

NEEDY ARTISTS ALLOWED IN CCC

WASHINGTON, July 11.—(INS)—Continuation of the public works of art project, which aids needy artists, was assured today for 100 of the younger ones, by allowing them to enroll in the CCC.

The artist-recruits will wear the uniform, eat the camp fare, and otherwise live the life, but instead of chopping trees, they will paint or draw them.

Messenger, Freemont, Ohio, July 11, 1934, p. 3.

Chapter 11

Changes In Camp

Once the threat of further carnage had passed and the stolen dynamite was returned to Estabrook Park, work projects continued, with the security modifications for the dynamite bunker remaining in place. Another change, which was quietly in the works for months, was made at the camp, as well. The U.S. Treasury Department Section of Painting and Sculpture approved the recommendation for a CCC artist, "to a Milwaukee camp."[95]

New CCC Artists Assigned

Edward B. Rowan, in Washington, D.C., authorized the enrollment of CCC artist George Thomas Burns and coordinated with Army authorities to have him assigned to CCC Company 1699, Camp Estabrook.

Arriving on November 12, 1935, the 23-year-old Burns, a single Milwaukee native and recent graduate of Milwaukee State Teachers College, expected to stay the full six months of his tour. He was among the luckier of CCC artists because his accommodations included a private studio space within the camp compound.

On March 9, 1936, Burns wrote to Rowan, explaining that during the three weeks he was adapting to camp life he'd made only sketches. Then an unexpected position opened up with a local WPA project and he resigned from Camp Estabrook:

> *"I am very grateful for having been given the opportunity of working and living in the camp . . . The opportunity for artistic development in such a position is excellent; it is a great thing to have such freedom of time, subject matter and choice of media as the position affords."*[96]

Ratti must have been aware that CCC artist Burns was in his camp, and perhaps become aware of opportunities now available to artists within the CCC.

Inside of six months, Rowan would assign another CCC artist to Camp Estabrook. Vernon Roy Stewart, age 30, was employed as an architect and draftsman before the 1930s' economic downturn. His first CCC artist tour was at remote Camp Dunbar in Wisconsin. After a year, Stewart requested a transfer to Milwaukee "for the good of the service."

Within a month of Stewart's arrival at Camp Estabrook, he also found outside employment and resigned April 18, 1936.[97]

Ratti Ready for a Switch

During this time, Ratti was in communication with friend Ted Bonnickson and learned that Bonnickson's application for a status change to CCC artist enrollee was approved by Rowan, in Washington D.C.

Ratti was growing artistically and, on many levels, in self-assurance. He continued to draw and sketch the CCC world around him, while experimenting with different mediums, including woodcuts, sculpture and mural painting.

Ratti's CCC art was being recognized, exhibited and published in the local newspaper. He continued his studies at the Minnapolis Art Institute (MAI) and was buoyed by winning a competitive sketch contest sponsored by *The Milwaukee Journal*. Of the 1,562 submissions, Ratti's drawing was judged worthy of a second-place award. It paid $5 cash; a welcome to sum compliment Ratti's monthly CCC allotment.[98]

By the summer of 1936, Ratti was ready for a CCC status change, one that required authorization from Rowan.

Records from August 1936 reflect Ratti did receive a status change, but not the one he was seeking. An emergency call had been put out by the Forest Service in Michigan. A massive fire was engulfing a remote island on Lake Superior. Isle Royale, the newest area designated as a national park, was ablaze.

Ratti, along with other Camp Estabrook CCC boys who answered the call, received an emergency transfer to Houghton, Michigan, and a work status change to "fire duty."

His desire to be an official CCC artist would be put off for the duration of this emergency.

Sagely, he packed his pencils and watercolors for what would be a memorable and grueling six-week assignment in the north woods.

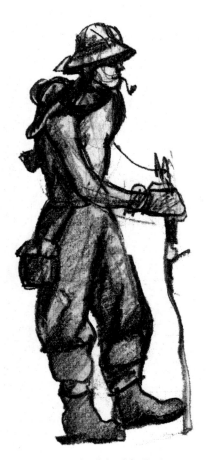

Undated sketch by Ratti

*Isle Royale is a thing of the past. It is only
a memory . . . It becomes increasingly harder
to remember the hardships we endured,
and much easier to remember all that was good,
and beautiful.[99]*

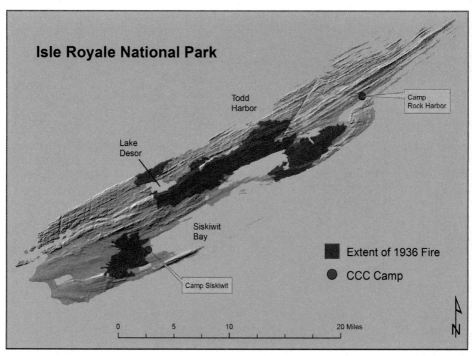

Isle Royale 1936 fire map.

Chapter 12

Enchanting Isle Royale

Isle Royale is the largest island far out in Lake Superior, covering about 210 square miles with an estimated 200 small islands and rock outcroppings. The main island is 45 miles long and is 8 miles at its widest point.

"Benjamin Franklin insisted that the boundary line between the United States be drawn north of the rugged island which is part of Michigan."[100] Its combined isolation, natural beauty, and wealth of prehistoric and early copper mining history make Isle Royale a unique, if not remote, island treasure.

Other portrayals have described it as the wonder island of the north and the enchanted isle and likened its bird's-eye view outline to a battleship accompanied by a fleet of destroyers. Indians of the 17th century feared the landmass and referred to it as a floating island.[101]

Although Isle Royale was not formally dedicated as a National Park until after World War II, the National Park Service (NPS) began administration of the island in 1935. By midsummer of 1936, the NPS had set up two summer CCC camps.[102] They were: Rock Harbor, on the northern end of the island, designated as NP-2, Company 2699; and Siskiwit, in the center of the island as NP-1.

Poignantly, during July 1936, former CCC artist Marshall Davis, now a full-time staff artist and reporter for the CCC national newspaper, *Happy Days*, visited the newly established Rock Harbor NP-2 CCC camp, also known as the Daisy Farm; it was among his favorite assignments for the newspaper.[103]

The steamer that brought staff artist Davis to the island on one of its biweekly voyages would have also carried much needed supplies and food for the CCC camp. This steamer was most likely the *Seminole*, the only means the Army had to bring in provisions. Items and visitors were then ferried ashore on smaller vessels, which could navigate the rocky coast.

When he stepped ashore, artist Davis found wilderness, with no roads, horses or automobiles. The soil was rocky and rough, and its

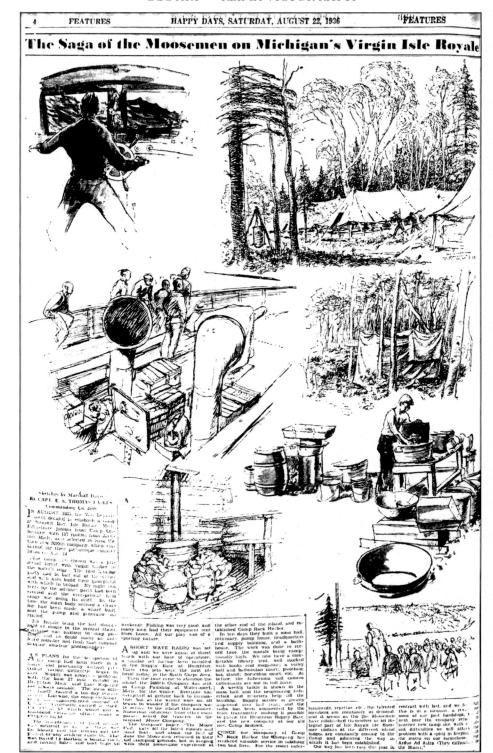

Happy Days, August 22, 1936, illustrations by Marshall Davis.

formidable rocky coasts had no sandy beaches. The new home of the CCC was two tent camps that housed hundreds of enrollees and technical staff. Work projects consisted of construction of buildings, trails, fire towers, docks and a mess hall. They were improvements Davis found on his arrival.[104]

The story of CCC Company 2699, NP-2, Rock Harbor camp and its work projects appeared in the August 22, 1936 edition of *Happy Days* as a full-page feature under the headline, "The Saga of the Moosemen on Michigan's Virgin Isle Royale." It was written by the commanding officer, Captain E.S. Thomas, FA Res, and richly illustrated by Davis. A copy of the paper would have been sent to the library at Camp Estabrook, but Ratti and many of the other Estabrook boys weren't there when it arrived. The reason: Disaster had struck on Isle Royale.

Wild Inferno

Ironically, the story was published the same week the remote and pristine island was submitting to a hot and dangerous wildfire. Ratti and more than 1,500 CCC boys were battling smoke, flames, ash and falling trees on what was now a water-bound furnace.

Typically, the history of fires in the Great Lakes region were in the fall, with wildfires a relatively rare occurrence on Isle Royale.[105] The summer of 1936 was unusual. Three years of drought created extremely low-moisture conditions, drying out of the shallow surface layer of leaf mold and moss, the humus in places was 12 to 18 inches deep. The massively destructive Greenstone forest fire began on July 25, 1936, near Siskiwit Bay, presumably set by careless campers or slashing (woody debris) left by the George W. Meade Lumber Company.[106]

Initially, CCC crews from the two camps on the island joined with loggers in an attempt to contain the hot wildfire, but were thwarted by high winds. The fire, which spread quickly to the north shore, was visible from 50 miles away. It would burn 33,000 acres[107] in the center of the island before it was contained months later.

Help Arrives

Some say a call for reinforcements came too late for fire-fighting manpower, food, tents and supplies to be sent to the CCC Supply Depot in Houghton, Michigan. However, it was answered by numerous CCC camps in Wisconsin, Michigan and Minnesota. Special trains rushed 460 CCC workers from Milwaukee, Wisconsin.[108] Others, like the recruits from Company 1699, Camp Estabrook, traveled in truck convoys hundreds of miles.

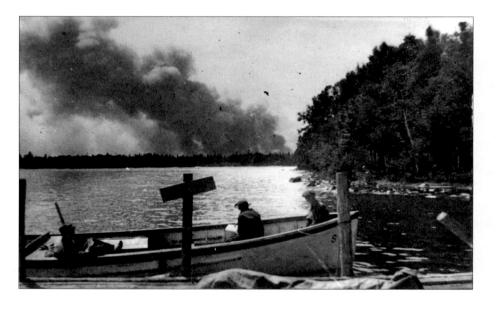

Caption on the back of photo: "Forest Fire Destroys Lake Superior Beauty Spot. Men in boat on one of the bays on the shoreline of Isle Royale, Michigan, watching the forest fire, which has been burning for a week, destroying the trees on the island and causing the residents to leave for the mainland," August 11, 1936. Authors: Acme News Picture collection.

These "Isle Royale Memories" would be shared and artistically detailed months later, beginning in February 1937, when Camp Estabrook newspaper, *Skipper's Scandal*, would once again be published by the camp enrollees. This resurrected version of the paper would be richly illustrated by Ratti, the new editor who also had been granted the official status of CCC camp artist.

Memories of Isle Royale

"Hold up that truck."

"What are we waiting for?"

"Hey, you, stay on that truck."

"Lord, won't we ever get started?"

"Twenty-six hours since we left Milwaukee, and still a long boat ride ahead of us before we reach Isle Royale. Down the road behind us, a string of headlights marked the position of the rest of the convoy . . . The shrill blast of a whistle rent the night and our truck rolled slowly down the long twisted road . . . the truck pulled up to the docks with a squealing of brakes. With our barracks bags on our shoulders, we climbed off the trucks and lined up on the dock . . . Five minutes later, we were sweating and cursing under the driving voice of the officer in charge of loading supplies."[109]

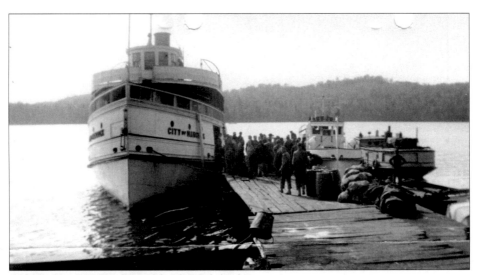

CCC boys board the *City of Hancock* for Isle Royale fire duty.

Ratti sketch, which appears to be a depiction of the memorable Lake Superior Isle Royale voyage.

The CCC fire brigade Company 1699 from Camp Estabrook, Milwaukee, had arrived in Houghton, Michigan, on August 11, 1936. After spending the day putting up and then taking down tents, they crossed the gangway and climbed the stairs to space allotted them on the stern deck of the steamer.

> *At 11:30 p.m. a long blast came from the whistle and the steamer carrying the CCC boys moved into the channel and made for the open water of Lake Superior . . . The boat nosed its way slowly thru the Houghton swing bridge. The span was lined with people, mostly girls, who were out to see the CCC boys off for Isle Royale. They were laughing and waving gaily, a few of them blew kisses. The ship was so crowded that the boys were lying on the deck like a flock of sheep . . .*[110]

Ratti illustration, *Skipper's Scandal*, March 1937, p. 8.

*We passed the breakwater into Lake Superior and left
the shores of Upper Michigan behind. As the boat began
pitching gently and a cold wind swept in from the lake,
the boys gradually settled down for the night.*[111]

At about 8 a.m., Wednesday, August 12, 1936, after nine and a
half hours, the boat dropped anchor . . . the CCC boys from Camp
Estabrook finally arrived at Rock Harbor, NP-2.

Less-Than-Enchanting Isle

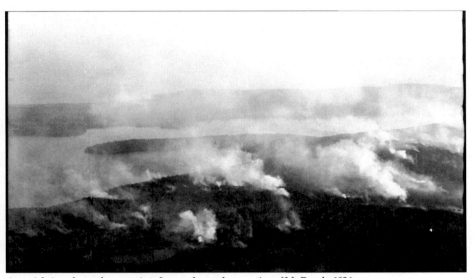

An aerial view shows the extensives fires on the northern section of Isle Royale, 1936.

A total of 600 CCC boys from multiple Wisconsin camps disem-
barked that day.[112] They arrived at the same Rock Harbor camp *Happy
Days* artist Davis had visited weeks earlier.

"In a little clearing in the forest lay the camp, which for the next six
weeks was to be our home."[113]

It was no longer a tranquil setting, however.

Ben East, a respected *Grand Rapids Press* conservation editor visited
the island, spending three days at the CCC Siskiwit, NP-1 camp.

*I flew over the entire fire area in a navy seaplane that
was making a complete patrol of the island three times a
day . . . it was a sorry picture.*[114]

The fire crews have had to rely on mainly hand and marine pumps . . . every foot of trench on the fire front, more than 100 miles long, has been dug by hand, hewn out of the hard soil with ax and shovel and mattock by sweating manpower. . . I am not in any sense a trained firefighter . . . But I do know courage when I see it, and the CCC lads on the Isle Royale fire have shown plenty of it.[115]

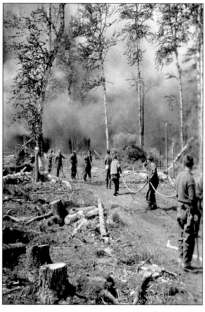

Hoses and water pumps were carried inland by the CCC boys to fight the fire.

Calling the CCC fire brigade "the largest fire army" to ever fight a single blaze in Michigan, East detailed the conditions and their grueling 12-plus-hour shifts, day and night . . . 19 days without a break and explained how the soil compacted with leaf mold and humus, burned itself.

Carrying fire-fighting equipment inland was exhausting for the CCC enrollees, Ratti sketch.

He further clarified . . . though there was an abundance of water, portable pumps and hoses needed to be carried inland. The pumps were powered by gasoline, necessitating the hand-carrying of 10-gallon gas tanks weighing 80 pounds.[116]

When the Camp Estabrook boys first arrived on Isle Royale, they set up camp, had dinner, then they were sent into the fire line.

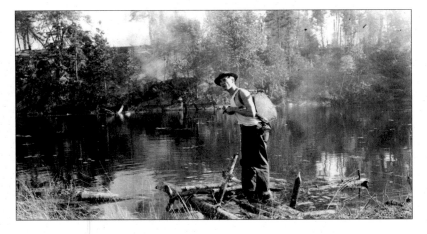

Water tanks were filled for the fire pump.

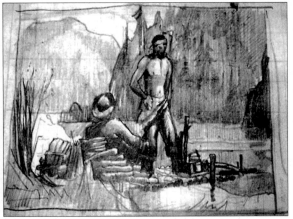

Fire pump crew, resting and at work.

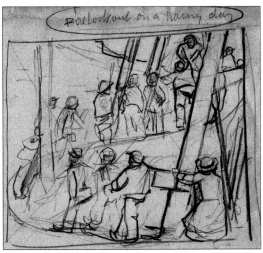

Ratti fire duty sketches: untitled (left); *Fire lookout on a rainy day* (above).

What an experience! The fire was hotter than blue blazes. My feet felt as tho they were afire . . . (after about two weeks,) we got some fire pumps and then the fun began. They leakes (sic) all over us and then our shoulders started getting sore; after carrying one for a couple of hours we were plenty glad to sit down and rest. We fought a number of hot blazes and [Company] 1699 made a name for itself.[117]

Meanwhile, back at base camp:

Tent No. 1 was a veritable casino. Crap and poker games were going all night, the sky was the limit . . . (Enrollee) Curtis took first prize for ability to get out of work. One morning, he disappeared on the way to work and did not show up until almost quitting time.[118]

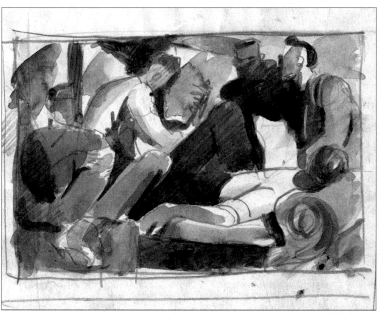

Many of Ratti's sketches and watercolors depicted CCC life in the barracks.

Hike to the Blaze

One morning, the fire crew from Camp Estabrook awoke to the announcement from platoon leader Peckham "that our patrol had been changed to Dinnerplate Lake. That gave us about a twelve-mile walk, night and morning . . . It was really tough going part of the way."[119]

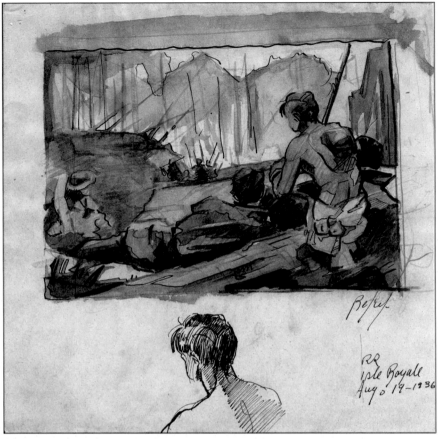

Relief by Ratti, Isle Royale, August 19, 1936.

Prior to any trails made by the CCC, the estimated 12-mile hike from Rock Harbor would have been in a southwesterly direction, toward the fires burning inland on the Greenline Ridge, and may have been what is now known as Hachet Lake.[120]

> *(Upon arriving at the lake) it appeared the meanest man in the woods had been at work out there, for about every tree was ablaze. The forester in charge couldn't find the lake, so Peckham had to show him how to get there. We promptly nicknamed it, the Lake of the Lost Forester. We spent about a week and a half hunting for spot fires and toward(s) the last, they became rather hard to find. Our noon-day meal in the woods was unappetizing. Cheese and green bologna get mighty tiresome if you eat them every day.[121]*

The Spring 1937 edition of *Skipper's Scandal,* featured illustrations by Ratti and Part 2 of "Memories of Isle Royale", a detailed article relating to the companies fire-fighting adventures the previous fall.

Chapter 14

Inspector Hannon's Findings

Maintaining two CCC camps was a logistical challenge in the best of circumstances and a nightmarish scenario in an emergency. Under normal conditions, each of the two Isle Royale CCC camps had been 160 enrollees strong. Meeting the needs of housing, food, medical care, transportation and supervision had already proven demanding for this small group.

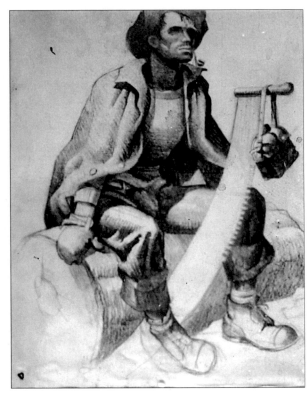

Possibly titled *Fire Fighter at Rest,* this undated Ratti sketch appears to be the depiction of a CCC laborer on fire-fighting duty

Agency Infighting Fuels Operational Problems

Before the fire, tensions existed between the National Park Service (NPS), which administered the island and work projects, and the Army, which administered the CCC camps. Both agencies had base headquarters and supply offices in Houghton. Their discord would be exacerbated by the sudden influx of CCC boys and the most sensible way to manage a fire of this magnitude.

The NPS controlled and directed the fire-fighting work patrols, chartered several small coast vessels, and had the use of three seaplanes from the Naval Station solely for observation purposes. The

War Department had chartered the *SS Seminole* for $400 per trip. This steamer would bring enrollees, equipment and supplies to the island twice a week. Perishable foods were stored in the cold waters of Lake Superior.

It was estimated during August 1936, an additional 1,230 men were brought to Isle Royale to fight the fire, bringing the total to 1,541 enrollees on the island. Added to that were 115 Park Service supervisors, officials and some 30 or more civilians and officers from the army.[122]

On August 20, 1936, J. D. Coffman, chief forester of the National Park Service, and William Endersbee, field coordinator, flew to the mainland to register protests with army officers at Fort Brady, Sault Sainte Marie, Michigan. Their complaints were about food shortages, bad food and improper sanitary conditions. An epidemic of mild dysentery had swept the camps. This was reported in scathing articles in the *Grand Rapids Press* by Ben East, who was especially critical of the Army, but supportive of the CCC boys.

When CCC Assistant Director James McEntee in Washington, D.C., heard there were problems on Isle Royale, he quickly dispatched special investigator William P. Hannon of Chicago to access the situation. Hannon, an experienced CCC agent, was the same investigator who reported on the Milwaukee CCC dynamite theft and bombings the year before.

Like Hannon, many CCC investigators were former union members. Several were still associated with the Machinists Union; the same union for which CCC Director Fechner had served as a vice president.

CCC special inspectors were often drawn from the ranks of labor coalitions. They focused their investigations on the workers and working conditions. They weren't beholden to the Army, the NPS, the Forest Service or any other government agency, but they were part of an independent and cooperative agency.

With respect to the CCC boys and the camps, the investigators' reports were based on visiting the work projects and judging the conditions of equipment, safety measures and tools. They also evaluated each camp's conditions regarding sanitation, living, housing, menus, education, clothing, entertainment, safety and morale. With each inspection, they interviewed enrollees and staff and initially

looked for any communist-leaning literature circulating in the camps.

Their only priority was the treatment of the CCC boys and the conditions in which they were living and working. It was with this objective and mindset that Hannon approached the unusual conditions presented at Isle Royale during the fire emergency.

When Hannon arrived on the island, it was a few days after reporter East—who had visited only one CCC camp—had published his first scathing article.

Notice of CCC Inspector Hannon's Isle Royale planned visit to SP-1 would have been posted on the Camp Siskwit bulletin board .
NACP RG 35, E115, Bx5, NP-2

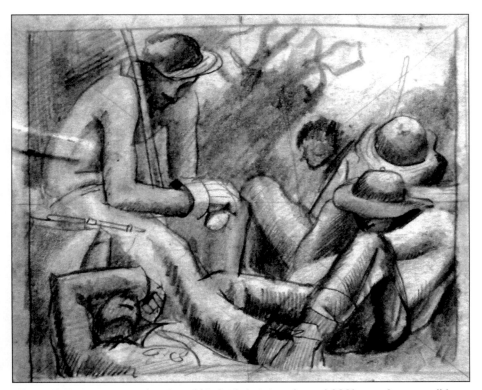

Siesta, a title Ratti gave to several versions of this sketch depicting exhausted CCC boys as they came off the fire line.

CCC Investigator Evaluates Conditions

Hannon was able to visit NP-1, at Siskiwit, and NP-2, at Rock Harbor. With no transportation by way of roads, it was impossible for Hannon to visit the side camps. A request for the NPS to allow him to observe the fires from the air and possibly visit the side camps was declined. Two of the three planes were "laid up," and the third was needed for observation.

An announcement of Hannon's CCC upcoming inspection was posted at both camps. Interviews with enrollees, Army commanders and the NPS were conducted.

Hannon reported the nights were very cool and found that there was a lack of mattresses and blankets, and considered the food only "OK."

He sympathized with the NPS challenge of handling the fires. "This is a most unusual condition here, with a large number of men, in the most northern part of the Upper Peninsula, with poor transportation . . ."

He also noted the Army was doing its best to correct the conditions found lacking by the NPS.

Still, the inspector's most critical assessment and concerns were with the NPS. He stressed that the situation was serious and found the CCC boys were being overworked.

Following several interviews, he established that the NPS had the CCC boys working three shifts, seven days a week, with no rest. The first shift was awakened

The unrelenting physical demands expected of the CCC boys fighting the fires concerned CCC Inspector Hannon; undated Ratti sketch.

at 4 a.m. Shifts overlapped by one hour, allowing the first shift to quit with no interruption with firefighting. This would allow the next shift to get a good start. However, some of the men were walking five to six miles to and from their base camp to the fires, making the days 10 to 12 hours long. In some documented cases, the workday was 15 hours.

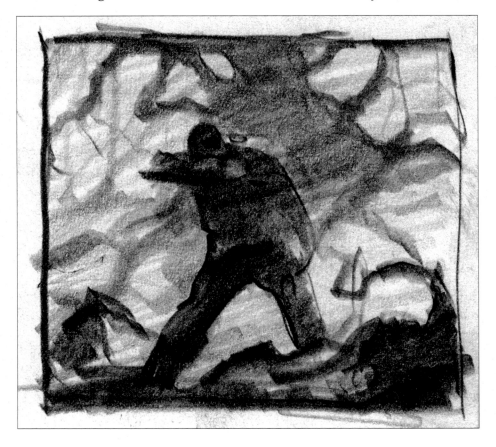

Hannon cautioned CCC authorities in Washington: "It is going to be very hard to hold men in the camps, if they are to be worked so hard." He noted that the week before, on August 18, there had been a shift in the winds and a heavy downpour, leading to containment of the fires. He reasoned, the fires, while still burning in the ground, were fairly well-contained.

You cannot declare an emergency and continue it after the fires are under control and keep on working these men unreasonable hours without giving them the rest needed and some time for recreation, he wrote.

Hannon spoke with Coffman, the chief NPS forester on the island, who "said he planned on releasing the pressure on the enrolled men, by giving them a day's rest during the week. I urged him to put it in to effect as soon as possible."

Inspector's Recommendations

Once Hannon returned to the mainland, he sent Assistant CCC Director J.J. McEntee in Washington, D.C., four pages of standard camp inspection reports along with three pages of assessment and strongly worded recommendations.

Hannon warned, "the waters are dangerous here, boats anchor outside, or away from shore . . . there was a possibility of overloading them . . . they may capsize . . . the sea is rough." Hannon also noted that the NPS wanted to keep the CCC boys until November 1, but the Army felt they should be off the island by September 15.

Hannon strongly advised the CCC to immediately start withdrawing the extra men on the island and then get the balance off no later than October 1.[123]

Fire Duty Ends

The boys from Camp Estabrook were off the island eight days after CCC authorities in Washington, D.C., received Hannon's reports.

When word finally came they were going home . . . Ratti packed his bedding, duffle bag and apparently some drawings and watercolors from the August 10 to September 16, 1936 tour:[124]

> *Everybody turned out before daybreak to make final preparations . . . It was raining a nasty drizzle, but everybody was happy . . . They loaded onto the* Mary Margaret, *a supply boat . . . which was to transport them out to the steamer SS* Seminole *for the return trip to Houghton. The water was rough . . . the bobbing motion of the boat almost made them seasick as they waited and waited . . . Finally an officer came and reported that the SS* Seminole *was just outside the harbor, but was 'afraid to come through the strait' . . . They returned to Rock Harbor, disappointed to spend another night on the island.*[125]

The next day, the waters were still rough. The seasick boys of Camp Estabrook boarded the *SS Seminole* returning them to Houghton. Then they took a "long tiresome train ride" back to Milwaukee.

Employment records for the returning CCC boys listed their grueling five-plus-week assignment as "detached service" and "fire duty". This status would revert to "laborer," except for Ratti. He was now ready to make an application for a status change to "artist enrollee."

> *I have heard much about CCC Artists and the fine work they have done. I would very much like to be a CCC Artist myself . . .* [126]
>
> Sincerely yours,
> Reima Ratti

Reima Ratti's wish to become a CCC camp artist became official after he wrote to Edward Rowan at the Treasury Department. This divided illustration by Ratti may be a self-portrait, depicting a letter being composed and an artist at an easel; Skipper's Scandal, Spring 1937.

Lasting Impression

It is unclear which finished art Ratti brought back from the island after the fire in 1936 and which pieces he created later.

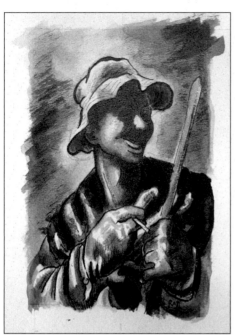

The experience made such a profound impact that, for months and years afterward, he continued to make illustrations, sketches, paintings and portrayals of Isle Royale and the CCC fire-fighting efforts. He was captivated by the island as much as by the CCC fire-fighters and returned four years later with another Waukegan artist to sketch and paint "the wonder island of the north."

CCC Fire Fighter, No. 1, perhaps December 30, 1943

Even in 2018, "Isle Royale National Park has the lowest number of annual visitors, but the highest number of return visitors."[127]

Pencil notations on the reverse of these *CCC Fire Fighter* watercolors include the titles and dates "Dec 30 -43," possibly meaning 1943, and perhaps used for exhibits in 1943.

Both are part of the Reima "Ray" Ratti collection at the Bess Bower Dunn Museum Lake County in Libertyville, Illinois.

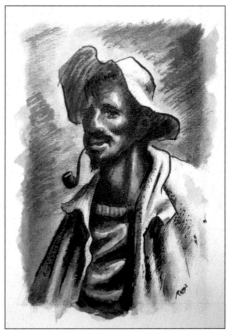

CCC Fire Fighter, perhaps December 30, 1943.

Chapter 15

Reima Ratti, CCC Artist

Once back in Milwaukee, Ratti wrote to Edward Rowan, at the Treasury Department Section of Painting and Sculpture in Washington D.C.

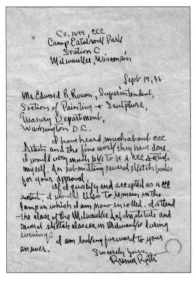

Ratti wrote Edward Rowan requesting approval for a status change to CCC artist[138].

"I would very much like to be a CCC artist myself. I am submitting several sketch books for your approval," he wrote. He also asked to remain at the Estabrook Park camp.[128]

Rowan responded in the affirmative and honored Ratti's request to remain at the Milwaukee camp. This change became effective retroactively September, 16, 1936, the day he returned from Isle Royale.[129]

For the next 10 months, Ratti concentrated his efforts on depicting the rock-busting work projects on the Milwaukee River and camp life. His drawings illustrate the drudgery and relaxation of a hardworking CCC company; boys who had deepened the Milwaukee River channel by 6 feet and widened the river to a minimum of 200 feet between the Hampton Road Bridge at Lincoln Park and the old cement mill dam near the Blue Hole. The boys removed 100,000 cubic yards of limestone from the the the riverbed.

By April 1937, it was planned that the last load of rock would move out and construction of a concrete and masonry dam would begin.[130]

Facing page, Ratti illustrations, *Skipper's Scandal*, June 3, 1937. Right: Ratti illustration of the three American Elm species found in Wisconsin, Skipper's Scandal, June 3, 1937.

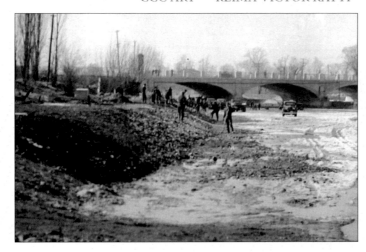

Left: Finished rock slope, looking upstream, from *Estabrook Park Project Reports, February to March 1937.* Below: Undated sketch by Ratti.

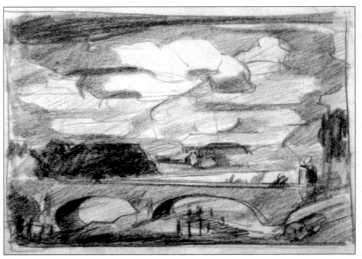

Illustrations of Nature and Photography

Camp authorities utilized Ratti's talents to improve signage in the camp and around the projects. The educational department used his illustrations for a new course and articles on botany. His oil paintings decorated the mess hall, library, camp offices and the canteen.

When the camp newspaper, *Skipper's Scandal,* was reactivated in February 1937, Ratti became art editor and sent Rowan copies. He also forwarded watercolors, black-and-white drawings and some oils and promised to send a painting he was working on—"a large oil of a group of forest firefighters."[131]

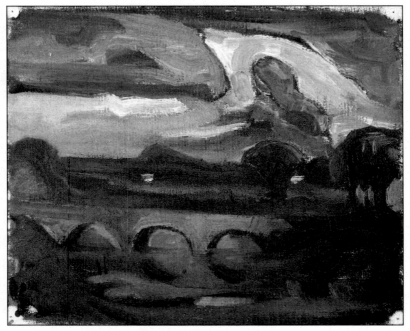

Bridge Over Water, oil on canvas by Ratt

Every other month, when park management submitted its pictorial project narratives, Ratti, now the camp photographer, took pride in providing the images and designing the covers for these reports.

Student Turned Teacher

Once the semester was over and he was no longer attending classes at the MAI, he supervised a sketching class at the camp.[132]

His visits to nearby CCC camps can be found in his drawings. During this time, he also completed sketches of the local foliage.

Ratti was fortunate to be in a CCC camp where authorities appreciated, encouraged and promoted his artistic efforts. He met with the camp educational adviser on a regular basis to discuss openings in the arts and

Article regarding Ratti's sculpture *Days Work Done - C.C.C.,* published in the *Skipper's Scandal,* May 25, 1937.

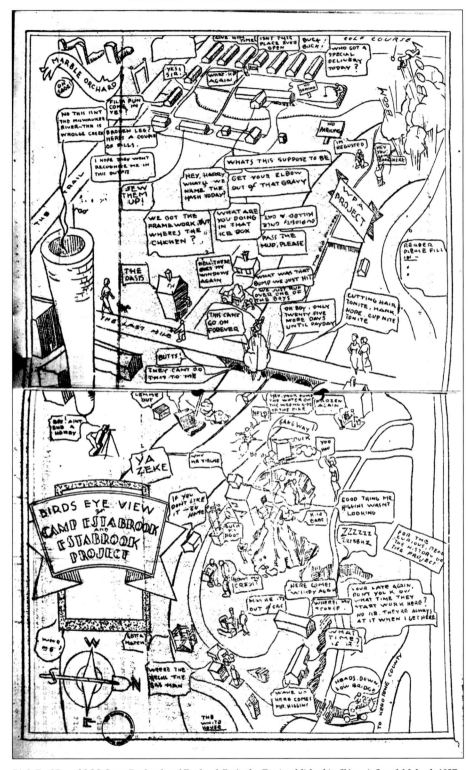

Birds Eye View of CCC Camp Estabrook and Estabrook Project by Ratti published in *Skipper's Scandal*, March 1937.

opportunities in business. A major focus toward the end of his enroll-
ment was marketing and sales of his *Days Work Done—C.C.C.* statues.

Captain Frederic A. Sauger, the company commander and a former
public school teacher, personally promoted Ratti's CCC statues, even
delivering them to the Fort Sheridan headquarters. One statue was or-
dered for CCC Director Fechner in Washington, D.C., and "duplicates
having gone to Africa, Mexico, India and many parts of the U.S.A."[133]

By the summer of 1937, the average age of the new enrollees was
17. Ratti was 23 years old, and most of the Waukegan boys with
whom Ratti signed on had left.

In the 27 months Ratti was at Camp Estabrook, he managed to
accrue one and a half years of college education at MAI.

His last communication with Rowan was six weeks after he was
discharged and was back in Waukegan:

> *I left three paintings in camp with instructions . . . that
> the paintings be sent to you . . . One of the paintings
> I believe is the best I've done in my career as a CCC
> Artist. Thanking you for changing my status from a
> enrollee to a CCC Artist. Yours sincerely, Reima Ratti,
> September 3, 1937* [134]

When Rowan learned that the paintings were oversized, two were
30 by 22 inches and exceeded the allowable "frank for government
parcel post," it was decided that "those pictures" be allocated to
Camp Estabrook for decoration.[135]

The official CCC artist file for Ratti's art includes a notation that
three oil paintings were being allocated to the camp superintendent:
Big Mike, Fire Lanes on Isle Royale, and *A Typical Enrollee.*[136]

Within four years, April 15, 1941, the Estabrook Park CCC camp
closed; buildings, embellishments and any remnants of Camp
Estabrook were dismantled and liquidated.

Before Ratti left the CCC, a parting tease appeared in the *Skipper's
Scandal* camp gossip column.

> *What's the big attraction in Waukegan for our company
> Artist? Is it a blonde or a brunette, Ratti?* [137]

CCC Art Titles

Although Ratti was an official CCC artist for just under eight months, he was prolific in what he shipped to Rowan in the Treasury Department, Section of Painting and Sculpture. The clerical staff there kept a card file for received or known Ratti CCC art. In addition to copies of the *Skipper's Scandal,* Ratti sent Rowan at least 24 pieces of CCC art.[139]

Boy Carrying Soup Bowls, charcoal
Loading Sand Truck, Crayon *
In the Barracks, watercolor
Boy with Shovel, ink wash
Boys Digging, watercolor
Evening Paper, ink wash
Line Lookout, oil matted
A Fallen Giant, watercolor
Fire Fighter, watercolor
Forest Fire Patrol Boat, ink wash
Isle Royale, crayon
The Stuck Jack-Hammer, watercolor
Kibitzer, watercolor
At Mess, crayon
The Rock Chippers, crayon
The Rookies, charcoal
Signing the Payroll, charcoal
Sawing Logs, watercolor
The Stone Crusher, ink wash
Under the Bridge, watercolor
Ukelele Player, *watercolor*
Spring Painting, ink wash and watercolor
Fire Fighters' Rest, pencil and ink wash
Big Mike, oil **
Fire Lanes on Isle Royale, oil**
A Typical Enrollee, oil **

Cover of the February 1937 edition of Skipper's Scandal, illustrated by Ratti and sent to Rowan. RG 121, entry 142, box 5, NACP.

* allocated to Mrs. Maude. G. Shallenberger, president of the Wichita Art Association, Kansas

** allocated to CCC camp superintendent, SP-5, Milwaukee, Wisconsin, possibly the three oils Ratti left at Camp Estabrook.[140]

Chapter 16

Found Himself 1937–1945

. . . there is a quiet conviction, that he (Ratti) is on the right road, that he has found himself. [141]

June Blythe, *Waukegan Post* staff

On July 18, 1937 an ideal summer's day was forecast for Milwaukee; the heat and humidity from the previous 10 days had lifted. The night before, the city celebrated the opening of the fifth midsummer Milwaukee festival.

Front-page stories declared Japan and China were nearing a breaking point, with war unavoidable.[142] There were updates "from the aircraft carrier *Lexington* in the South Pacific that another unsuccessful day had passed in the aerial search for the lost flyers"; the search for Amelia Earhart, the first female aviator to fly solo across the Atlantic Ocean, and navigator Fred Noonan would soon be called off.[143]

For Ratti, this would be a banner day. His CCC tour had come to a fruitful end.

As per regulations, he received an honorable discharge and transportation back to Waukegan because he'd secured full-time employment. With a firm conviction in his abilities and confidence in his direction; Ratti would become a baker by night and artist by day.[144]

Creating a Workspace

Ratti wasted little time reconnecting with friends from high school and other Waukegan artists. Together, they became members of the recently established Lake County Art League.

With fellow artist and friend Roland Hellman, he formulated a design for a studio—a space where they could create.

"Drawing on their own plans and specifications, the young men performed all the labor themselves, even to the magnificent skylight in the north wall. After eight months, they moved their tubes and canvasses into the new quarters."[145]

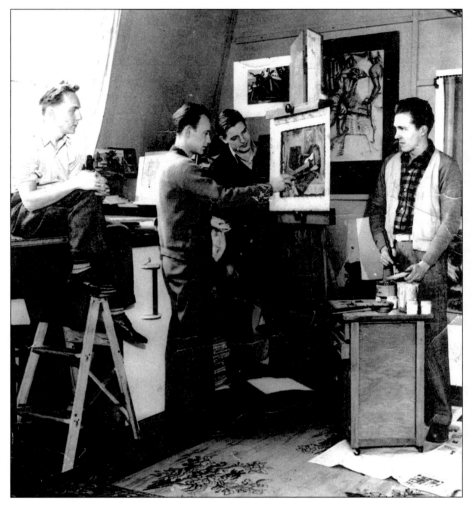

May Street studio, circa 1939, preparing for exhibits at the Karcher Hotel and the Chicago Institute of Arts (CIA) annual exhibition by local Chicago artists. Left to right: Carl Austen, Reima Ratti, Donald Mackay and Roland Hellman (courtesy of Cheryl Rae Ratti Coggins).

"We all worked hard," Ratti said, "and mother appeared at the most opportune times in the morning and evening, with coffee, and it surely helped a lot."[146]

Ratti's studio became a well-known gathering place for artists in Waukegan. It was a unique space to create and congregate. It also provided Ratti with a classroom workspace to resume teaching.

His full-time job as a night-shift baker with the Co-operative Bakery on McAlister Street afforded him an income of $72 a month[147] and the opportunity to paint during daylight hours.

Beginning in July 1937, Ratti worked the night shift at the Waukegan Co-operatvie Bakery. This sketch by Ratti is undated (author's collection).

Ratti's art often depicted the things he knew, the people he was close to . . . wandering the city with his sketchbook, much like the CCC camp, he would capture the life of the working-class sections.[148]

His former teacher, Robert von Neumann, had encouraged his student to "paint the things he knew and loved, and to depict the cares and woes of his fellow men" . . . to paint "the solid things and people close at hand."[149]

Ratti would frequent the Finnish baths in Waukegan to sketch. *Bath House Scene* and *Nude Study of Young Man Carrying Pail* are pastel on paper (courtesy of Bess Bower Dunn Museum).

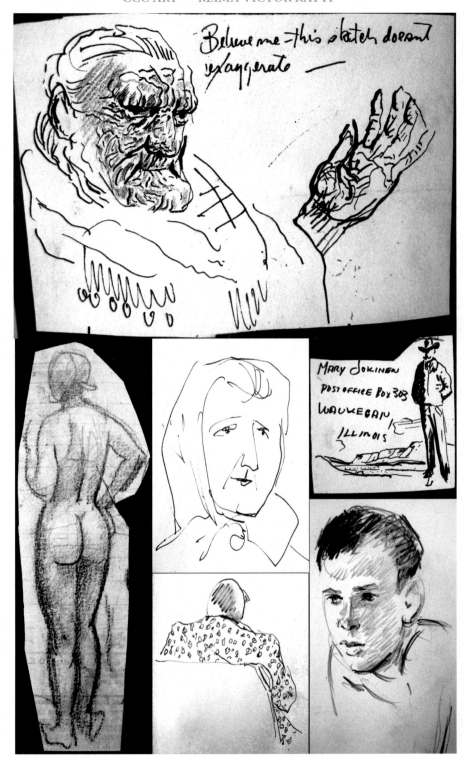

Drawiings and notations found in the Reima "Ray" Ratti sketchbook collection.

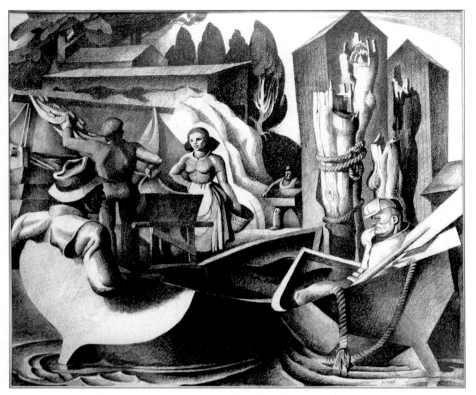

Bringing in the Catch, an impressionistic view of the local fish docks, is a pencil sketch Ratti frequently worked on while talking on the phone. "Some fancy doodle," is part of the description on a yellowed and brittle typewritten label attached to the frame of this piece. The label may have been written for display by artist friend Carl Austen, who arranged exhibits of Ratti's art in the 1950s or 1970s.

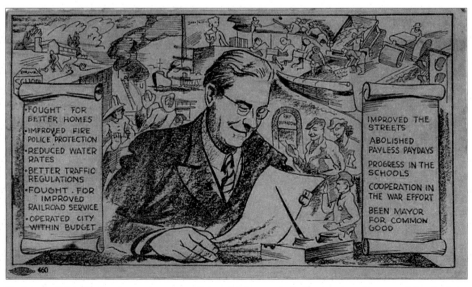

Ratti availed himself of various means to supplement his income, including creation of commercial art for the successful campaign of Frank G. Wallin, Waukegan mayor, 1941–1946.

Misplaced Credit

The Ratti family's Finnish connections were deep and complex; a branch of the Harju family was even a close back-fence Waukegan neighbor. Always one to help, Ratti seemingly made a financially struggling college student and apparent relative Sulo Harju of Rhinelander, Wisconsin, a generous offer.

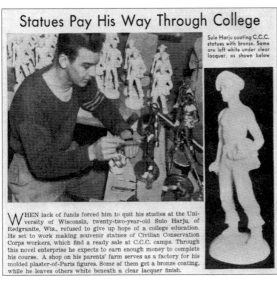

Statues Pay His Way Through College

Sulo Harju coating C.C.C. statues with bronze. Some are left white under clear lacquer, as shown below

WHEN lack of funds forced him to quit his studies at the University of Wisconsin, twenty-two-year-old Sulo Harju, of Redgranite, Wis., refused to give up hope of a college education. He set to work making souvenir statues of Civilian Conservation Corps workers, which find a ready sale at C.C.C. camps. Through this novel enterprise he expects to earn enough money to complete his course. A shop on his parents' farm serves as a factory for his molded plaster-of-Paris figures. Some of them get a bronze coating, while he leaves others white beneath a clear lacquer finish.

Popular Science, August 1939, p. 64.

The August 1939 edition of *Popular Science* magazine featured an article on the "enterprising" college student. Harju was pictured painting reproductions of Ratti's *Days Work Done – CCC* sculpture. The article did not mention Ratti as the original artist, and it appears Harju did nothing to clarify this.

Some of these statues, which Harju called *Days Work Done*, had a copyright—© 36 RATTI—etched into the statue base. Yet oddly, on another reproduction of this statuette which surfaced on eBay in 2017, the Ratti name is replaced with © 36 Harju.[150]

Harju, who had no apparent artistic training, was mass producing the plaster statuettes, which he varnished or painted bronze and sold at CCC camps. He never returned to college, but relocated to Waukegan where he worked as a salesman in a retail clothing store.[151]

Two of these statues, with the *© 36 RATTI* inscription, are believed to be gifts by Ratti to his Uncle Iver Hiibacka in Wyoming. Several were donated, in the 1980s or 1990s, to museums by former CCC enrollees.

Top: the Harju copyright. Bottom: the Ratti version.

Brief Return to Isle Royale

In the summer of 1939, Ratti and close friend Roland Hellman hitchhiked north to Lake Superior.

For Ratti, this fulfilled a longing to return to the primitive world of Isle Royale to sketch and paint what was, once again, a remote and peaceful island.

When Ratti returned to Waukegan, he and his artist friends exhibited at the Lake County Art League show alongside Norman MacLeish, Chicago's WPA director of easel projects. Ratti chose paintings from his recent trek to Isle Royale.[152]

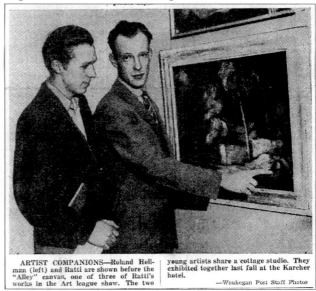

ARTIST COMPANIONS—Roland Hellman (left) and Ratti are shown before the "Alley" canvas, one of three of Ratti's works in the Art league show. The two young artists share a cottage studio. They exhibited together last fall at the Karcher hotel.
—Waukegan Post Staff Photos

Waukegan Post, May 3, 1940

Studio Influences Another Artist

Donald Mackey (1920–1983) was the son of John Maki and Hilja Harju of Waukegan. He grew up in a fractured and dysfunctional family. During his final high school years and later, Donald lived with the Ratti family on May Street. These living arrangements afforded the high school artist ample opportunity to paint Ratti's studio shortly after its completion. Mackey would not soon forget those who guided him while in Waukegan. As a World War II Army private in 1943, he funded a $300 art scholarship for a Waukegan student. He would go on to become chief technical designer and illustrator for the National Air and Space Administration (NASA) in Florida.[153]

By the mid-1950s, less than two decades after Mackey's painting was finished, the building was vacant of its artists and activity. Both Gary Ratti and Cheryl "Rae" Ratti Coggins, Melvin's children, remember playing around the structure.

By then the studio, which Hilja Ratti treasured, was now locked. It had become a dormant workspace, frozen in time, decaying . . . a sad reminder of Ratti's exciting and promising world.[154]

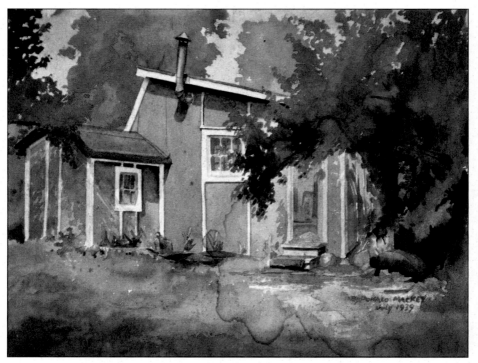

When shown the above image of Donald Mackey's 1939 painting, Ratti's niece and nephew recognized it immediately as Uncle Reima's studio, a locked and haunting structure they once played around. The undated photo, below, appears to show Hilja standing with an unidentified man outside Ratti's studio.

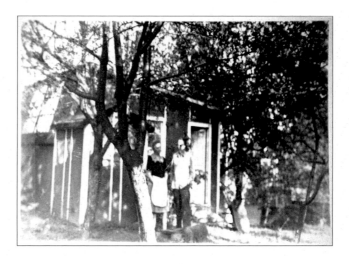

Chapter 17

Another World War

In July 1941, months before the bombing of Pearl Harbor, Ratti made applications for acceptance in the armed forces. He was ruled ineligible for military service. His Selective Service records do not detail why, but it is safe to assume it was a health issue, and a serious one. Deferred, he was ordered to report for a final physical examination April 8, 1943 "for the purposes of disclosing any obvious physical defects"; he would eventually be declared a permanent 4F.[155]

One of the works from Ratti's sketchbook.

The world changed after 1941, so many of Waukegan's youth, including the May Street artists, answered the patriotic call to serve their country during World War II. Ratti's brother, Melvin, served honorably but returned wounded.[156]

During this period, Ratti had established himself in Waukegan, even buying property in 1941.[157]

After four years at the bakery, Ratti found meaningful full-time employment as a window display designer with the Sears Roebuck and Company department store on Genessee Street in downtown Waukegan.

His mother, Hilja, who had struggled financially even before the death of her husband, Victor, continued to default on the May Street property taxes. In early 1943, a bond company purchased the tax debt.[158] A foreclosure was averted when the highest bidder–Ratti–paid $200 in fees and back taxes, but it was only a temporary reprieve.[159]

Challenged and Rewarded By Portraiture

The following year, Hilja's brother, Iver Hiibacka, died. Ratti accompanied his mother to Rock Springs, Wyoming, for the funeral. During that 1944 visit, Ratti painted the town, literally, in oils and was interviewed by the local newspaper.

Ratti's portrait drawings and sketches ranged from exact depictions to caricatures and abstractions. Top and bottom left: *The Kiss*. Right: untitled.

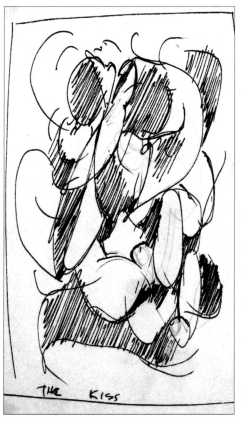

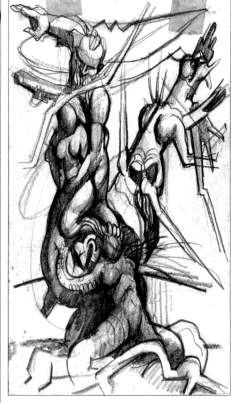

Untitled portraits, woman dated Feb. 2, 1935 (courtesy of Bess Bower Dunn Museum).

For the last two years he has engaged in portrait painting. 'I like to paint the person as I see him, . . . but most persons want to be flattered, they are disappointed if you catch a mood and portray it, even if a real painting is produced.' . . . Ratti has preferred to go along by himself and follow his own ideas. "'It takes a long time, . . . but it is the most satisfying method to an artist.'" [160]

Life was productive, secure and promising for Ratti during the early 1940s. Waukegan was a port city, meaning economic security was high during those World War II years, as the city contributed to the war effort. On August 17, 1944, Ratti was issued a civilian photo identification card by the Coast Guard. He had brown eyes and hair, stood 5 feet, 9 1/2 inches tall and weighed only 138 pounds. In this last known photograph of Ratti, he appears unsmiling, painfully thin, and aged beyond his 30 years. His sullen expression belies the fact that he was very happy. He'd met the woman he hoped to marry.

Ratti was in love with Mary.

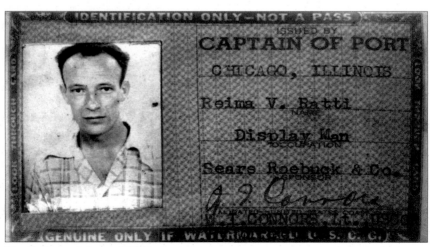

Identification card, August 17, 1944.

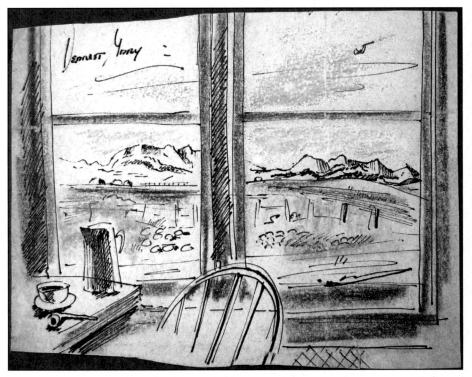

Dearest Mary sketch found in one of the scrapbooks treasured by Mary Joekenin (later Sadler), fiancée of Ratti; Bottom: A photograph of Mary's portrait published in an article about Ratti in *New Yorkin Utiset,* a Finnish newspaper (courtesy of Bess Bower Dunn Museum).

Dearest Mary

Working at the same Waukegan department store was a young woman who fell in love with Ratti, Mary (Perusky) Jokenin, a Sears Roebuck division manager.

Jokenin, who was in the process of a divorce, found the love of her life when she met Ratti. They became engaged but never married; time would run out.

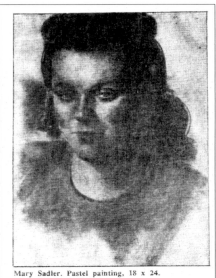

Mary Sadler. Pastel painting, 18 x 24.
Photo: Einar Jenstrom.

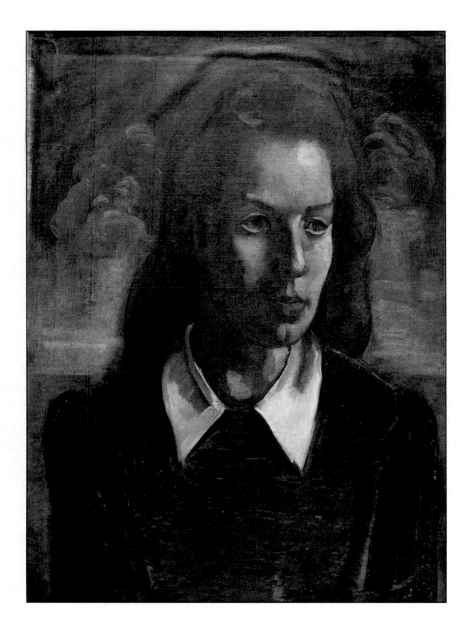

Portrait With Puffed Sleeves was among the Ratti paintings displayed in the *Odd Pieces* exhibit at the Waukegan Public Library. This 1976 show was described as "an art collection of love" because it was arranged by the woman who had been betrothed to Ratti, Mary (Jokenin) Sadler , and devoted artist friend, Carl Austen. In 2014, after Mary's death, this undated oil was among the pieces in the Reima "Ray" Ratti collection donated to the Bess Bower Dunn Museum by her daughter, Karen (Phillips) Sparkes. There appears to be a strong resemblance between the young women in the painting to the young lady identified as Mary on the previous page.[161]

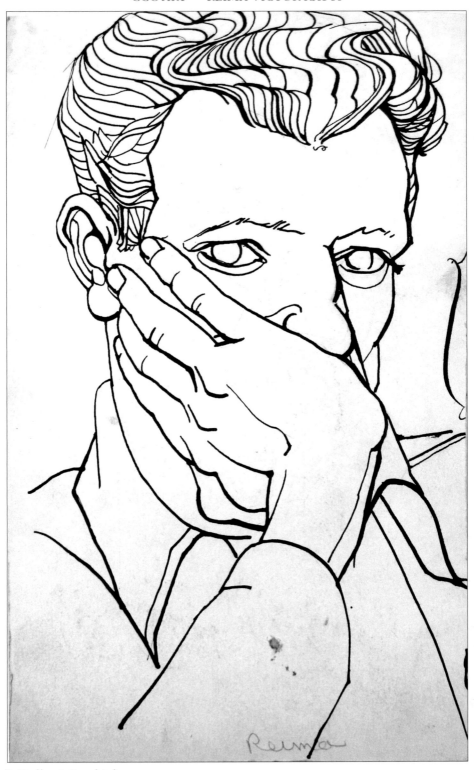

Ratti self-portrait, undated.

Chapter 18

Double Losses

*There are few stories in the history of medicine that are
filled with more errors or misconceptions than the story
of hypertension.* [162]

Marvin Moser, MD, clinical professor of medicine, Yale University

Almost two months before the December 7, 1941 bombing of Pearl
Harbor, 26-year-old Ratti reported for his military induction physical.
He was rejected. When he reported for another physical, two years
later, in April 1943, his classification became a permanent 4F.

The disability, which made him ineligible for military service, was
undoubtedly the diagnosis he received when he was just 28 years old
by Waukegan physician, Dr. Henry Holm, who termed it "hyparten-
sion (sic)."[163]

It is unknown what, if any, treatment Dr. Holm prescribed for
patients with elevated high blood pressure. Historical data shows
management of the disease in the 1930s and early 1940s was
primitive.[164]

> *A typical example of the course of untreated
> hypertension was that of President Franklin Delano
> Roosevelt whose blood pressure became elevated in 1937
> . . . and by 1941 reached dangerous levels. Enough so
> that Phenobarbital and massages were prescribed.* [165]

It wasn't until 1944, when cardiologist Howard G. Bruenn, a naval
officer, examined the president at the request of his daughter Anna
that the true nature of his ill health was recognized.

Dr. Bruenn was shocked by the president's condition.[166]

FDR Succumbs

On April 12, 1945, President Roosevelt was sitting for a portrait in the living room of the "Little White House" in Warm Springs, Georgia. He complained of a severe headache and lost consciousness. Fifteen minutes later, Bruenn examined the comatose president and recorded his blood pressure as 300/190mm HG. The president died soon thereafter. The cause of death was attributed to a cerebrovascular accident,[167] also called a brain hemorrhage or stroke.

FDR was 63 years old.

An Artist Is Lost

Seven months later, on November 12, 1945, Ratti was crossing a street in Waukegan and collapsed.[168]

He was brought to Saint Therese Hospital where, two days later at 2 a.m. November 14, 1945, he died. The official cause of death was cerebral hemorrhage. A notation on his death certificate stated Ratti had been suffering for the previous three years from "hypartension (sic)."[169]

Ratti was just 31 years old.

He would be interred at the Pine View Cemetery, now known at the Pine View Memorial Park, in Beach Park, Illinois two days later.

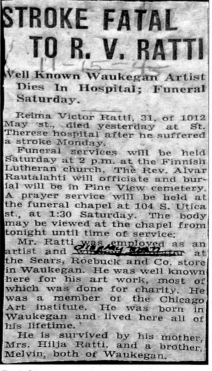

STROKE FATAL TO R. V. RATTI

Well Known Waukegan Artist Dies In Hospital; Funeral Saturday.

Reima Victor Ratti, 31, of 1012 May st., died yesterday at St. Therese hospital after he suffered a stroke Monday.

Funeral services will be held Saturday at 2 p.m. at the Finnish Lutheran church. The Rev. Alvar Rautalahti will officiate and burial will be in Pine View cemetery. A prayer service will be held at the funeral chapel at 104 S. Utica st., at 1:30 Saturday. The body may be viewed at the chapel from tonight until time of service.

Mr. Ratti was employed as an artist and ~~display man~~ at the Sears, Roebuck and Co. store in Waukegan. He was well known here for his art work, most of which was done for charity. He was a member of the Chicago Art institute. He was born in Waukegan and lived here all of his lifetime.

He is survived by his mother, Mrs. Hilja Ratti, and a brother, Melvin, both of Waukegan.

Ratti obituary

Heartbroken Survivors

Devastated by his death, his sweetheart felt God had forgotten her.[170] For decades, Jokenin salvaged, collected and "haunted . . . the Salvation Army in Waukegan and other resale shops" buying Ratti's masterpieces that someone tosses out.[171] Never parting with his art, scrapbooks, personal possessions and many of the Ratti family documents until she died in 2003.

Jokenin stayed in touch with Hilja and Melvin, even after she remarried in 1949 to Dean Sadler and had a child, Karen.

The Ratti's authorized Jokenin, now Mary Sadler, to sell Rattis's art and anything of value from the house and studio, but there is no evidence to suggest she ever did.

An Exhibition in Remembrance

It is apparent Ratti knew his condition could be life-threatening. Close friend and fellow artist Carl Austen believed there was "evidence that he'd gone through his work some time before his death and destroyed what he did not want left behind him."[172]

In 1953, eight years after Ratti's death, Austen mounted a double exhibition at the Waukegan library. The show, *Lost Art,* included 22 pieces by Ratti and an equal number by Austen. Ratti's pieces depicted views of Waukegan and many of its people, as well as scenes from other parts of Lake County that "had been found by Austen stacked in a closet at the May Street home."[173]

By 1956, Hilja was again in default on the May Street house, with back taxes due. By then, Melvin, who was now divorced from his first wife and had custody of his son and daughter relocated to Rock Springs.

Hilja, with the hope of always returning to Waukegan, moved to Wyoming to care for her two grandchildren The May Street house and studio were being rented, but it appears the person Hilja entrusted with collecting the rents and possibly paying the taxes proved to be untrustworthy. Melvin asked Mary Sadler to go over to the house to inquire about the overdue rent payments.[174]

On April 22, 1959, the May Street house, studio and lots were sold off in a tax sale, with the deed issued to the Interstate Bond Company; it would be resold later that year.[175]

Hilja, who never returned to Waukegan, died November 24, 1962. Melvin died August 20, 1974. Both are buried in the Wyoming Rock Springs Cemetery family plot.

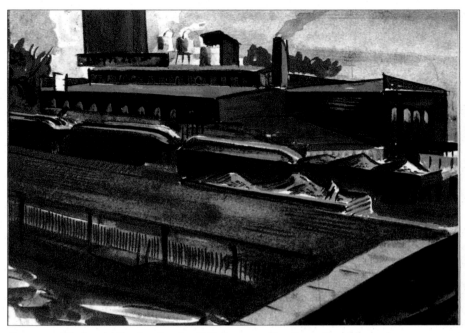

Downtown Waukegan railroad station, circa 1940s (courtesy of Bess Bower Dunn Museum).

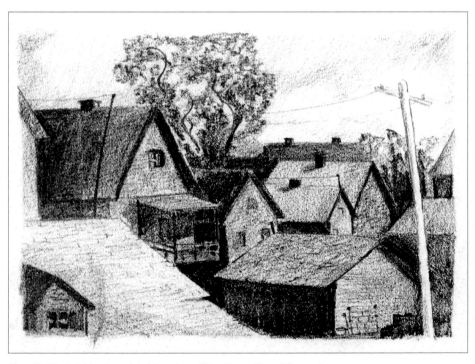

From Ratti's sketchbook, undated. (courtesy of Bess Bower Dunn Museum).

Chapter 19

Odd Pieces Exhibition

In February 1976, Mary Sadler joined forces with artist friend Carl Austen to organize a month long retrospective of Ratti's work at the Waukegan Public Library.

The exhibition was called *Odd Pieces* because, as Austen would explain, Ratti was so versatile in his abilities. He worked in oils, watercolors, gouache, pastels, sketches, woodcuts and sculpture.[176]

The exhibit was clearly an attempt to bring to light a forgotten Waukegan talent and, at the least, it was an exhibition of love for a friend, mentor and sweetheart.

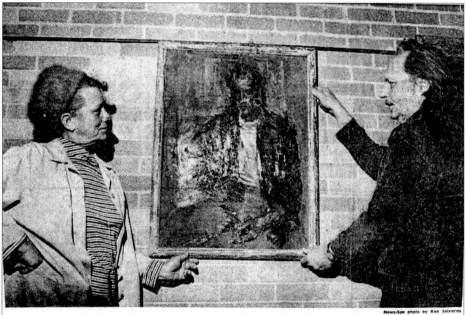

News-Sun photo by Ron Solyards

Reima Ratti: "A portrait of the artist as a young man" was done years ago by Carl Austen. Austen and Mrs. Dean Sadler, who was Ratti's fiancee before his death in 1945, are responsible for the exhibit of Ratti's works in the Waukegan Public Library.

Mary Joekinin Sadler (left) and Carl Austen adjust Austen's portrait of Ratti. Together they organized the "*Odd Pieces*" exhibit, featuring art by Ratti and Austen at the Waukegan Library, *Lake County News-Sun*, February 16, 1976

"Among the pieces were nude sketches from the Finnish baths, canvases painted of the fisherman on the lakefront and various angles of the Waukegan Chicago and Northwestern railway station."[177]

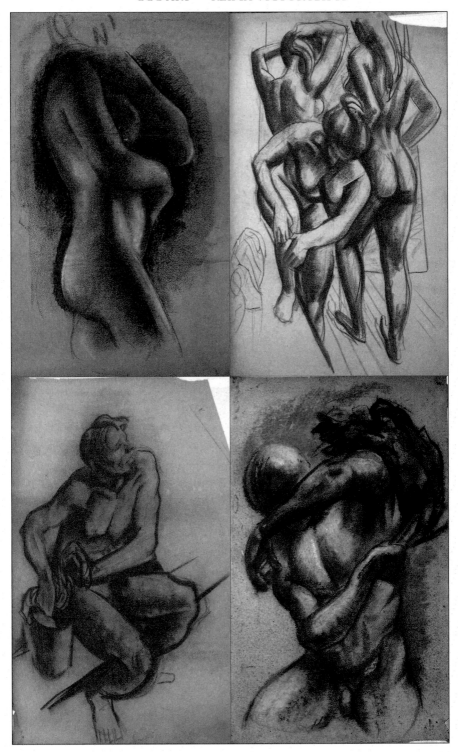

Nude studies, bottom Finnish Baths (courtesy of Bess Bower Dunn Museum).

Piccodelly Court, East of Washington & Sheridan and West of Tracks, Waukegan Illinois .

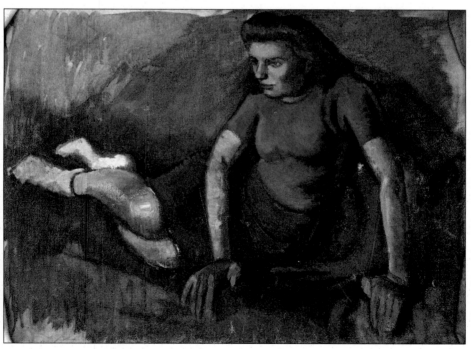

Untitled, February 2, 1935

Exhibits and Awards

Chicago Academy of Fine Arts - Scholarship 1933

1943 – Oakland Art Gallery, California

1953 – Lost Art, Waukegan library, Ratti and Austen exhibit

1976 – *Odd Pieces*, Waukegan library a retrospective exhibit of Ratti's and Austen's work

Milwaukee Public Museum (MPM) - Possibly *Chinese Jade Cutting*

The Art Institute of Chicago (AIC) sponsored the "Annual Exhibition by Artists of Chicago and Vicinity. Between 1941 - 1946 several pieces by Ratti were selected for these exhibitions:

1941 – *Girl Smoking;*

1942 – *A Spring Night*

1943 – *Harbor Tavern*

1945 – *Boatyard In Winter*, Oil

1946 – *Southbound*, Oil, Loaned by Hilja Ratti

Recognition in the Press

"The Soul of a Finnish Artist" was published in the September 24, 1991 edition of *New Yorkin Uutiset*, a Finnish newspaper. Sadler was aware of this story because a relative of Ratti's, Einar Jenstrom, contributed to the article. The hope was that "opportunities to show the work may surface or perhaps requests for placements of select pictures in Finnish-related cultural locations."[178] Jenstrom sent Sadler a copy of the paper, which she saved.

One of the four photographs featured in the article was an image of Ratti's 1936 *Days Work Done—C.C.C.* sculpture.

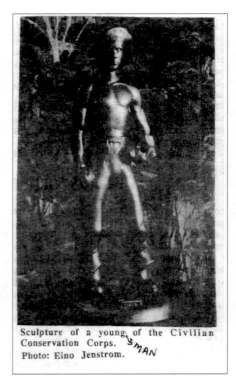

Sculpture of a young, of the Civilian Conservation Corps. *MAN*
Photo: Eino Jenstrom.

September 24, 1991 edition of *The New Yorkin Uutiset*

3-D, Life-size Remembrance

It is unknown if Jenstrom or Sadler knew that alumni of the CCC had formed the National Association of Civilian Conservation Corps Alumni (NACCCA), a nonprofit organization, or that it was planning legacy memorials.

NACCCA enabled CCC enrollees to share their unique "tree army" experiences. It also enabled them to see that the massive accomplishments of the Three Cs, now recognized as the greatest conservation movement in American history, were remembered and honored.

No doubt, Sadler and those who knew and loved Ratti, a talent they all believed died too young, would have been pleased to know that the CCC alumni would be profoundly influenced in their efforts to honor the CCC legacy by a small sculpture of an ideal CCC boy in their museum's collection.

The creator of this statuette, Reima Victor Ratti, was unknown to them, but his design was used as the model for a life-size bronze monument, the *CCC Worker* statue. It was a memorial the NACCCA hoped to see placed in every state, erected in the parks and forests to honor the CCC legacy.

A Sweetheart's Legacy

Mary Sadler died April 11, 2003 in Waukegan at age 87. When her estate was liquidated the following year, a final request she may have made was honored by her daughter, Karen (Phillips) Sparkes. A large donation of Sadler's treasured Reima "Ray" Victor Ratti collection was made to what is now the Bess Bower Dunn Museum in Libertyville, Illinois.

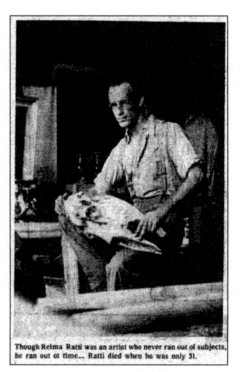

Though Reima Ratti was an artist who never ran out of subjects, he ran out of time... Ratti died when he was only 31.

The *Lake County News-Sun*, February 16, 1976.

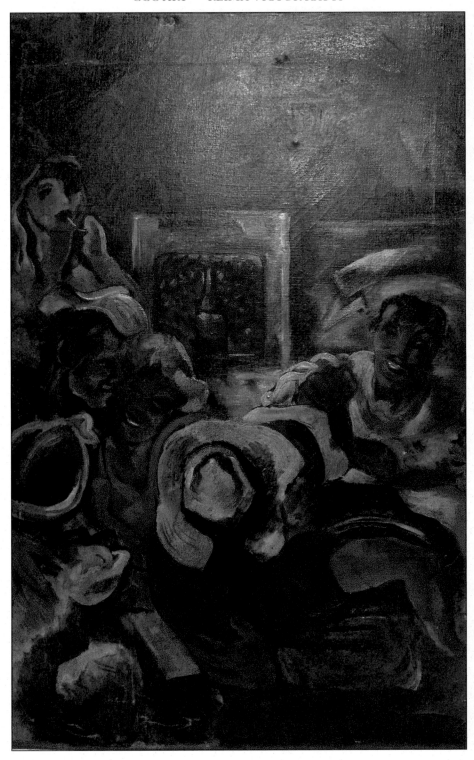

Bar At Night, oil on canvas, by Ratti (courtesy of Bess Bower Dunn Museum).

Chapter 20

Reima "Ray" Ratti Art Collection at Bess Bower Dunn Museum

Artwork on the following pages is from the Reima "Ray" Ratti collection at the Bess Bower Dunn Museum in Libertyville, Illinois, unless otherwise noted. Photography was generously permitted by the museum. Images were taken using existing room light and/or artificial ceiling lighting. Computer scanning or photography using artificial flash was not permitted.

Before the artwork was donated and became a museum collection, it was stored for decades in non-archival boxes and closets in close proximity to Lake Michigan, areas that experience extreme heat, humidity and cold. Some pieces appear to have fading, darkening, foxing or possible color shifts, while other pieces are vibrant and exciting.

For many of the sketches and scrapbook drawings, Ratti used whatever paper was available—the reverse of bakery order forms and inexpensive newspaper-like sketch pads, for example. Some of these papers have experienced an extreme yellowing with age, necessitating some adjustments with brightness and contrast for purposes of this books printing. When working at the bakery, he apparently drew on the circular cardboard discs typically used as bases for cakes. Several CCC Isle Royale drawings were on heavier, irregularly cut orange paper, possibly a paper used for wrapping. Few pieces are titled or dated.

These selections from the extensive collection are an attempt to show the talent and versatility of the artist, who made a difference by portraying what he knew and experienced, a talent who created with his heart and soul, but who departed this world too soon.

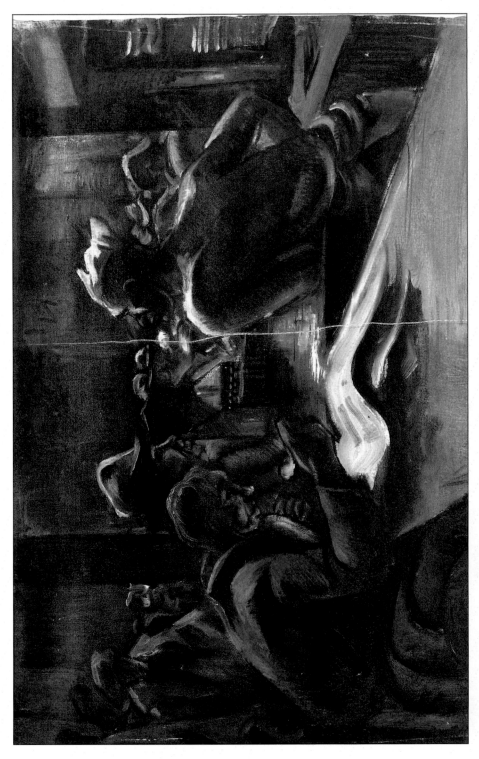

Bar Scene by Ratti, designated as an unfinished oil on canvas.

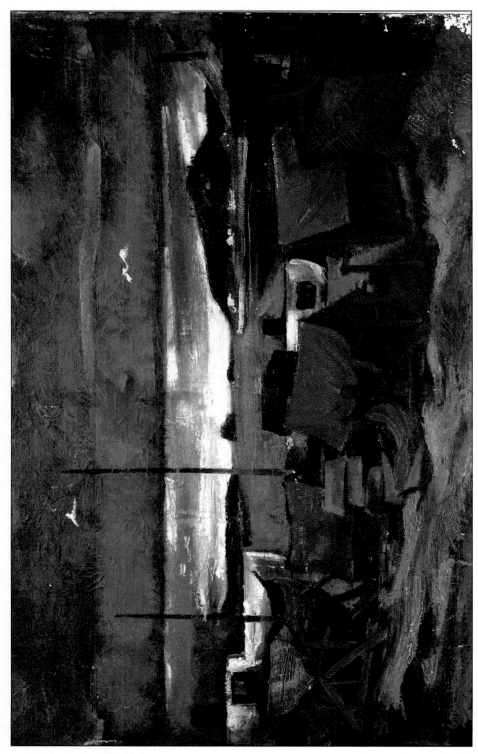

Nets by Ratti, oil on canvas

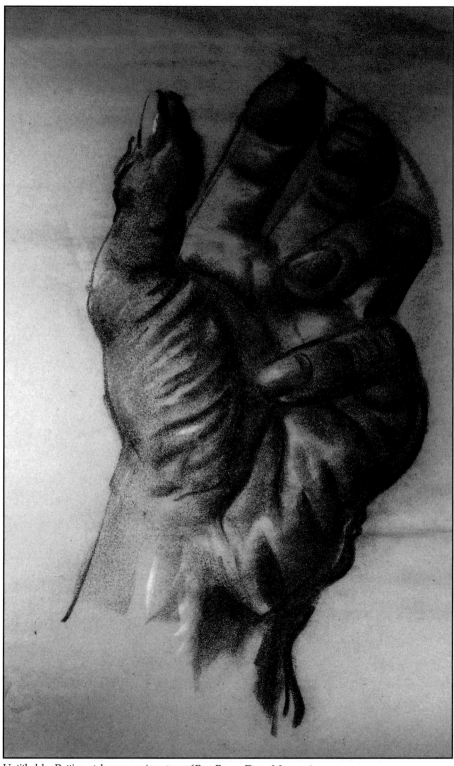

Untitled, by Ratti, pastel on paper (courtesy of Bess Bower Dunn Museum).

Landscape by Ratti, oil on board.

Portrait of Women With Cigarette

Wyoming by Ratti, oil on masonite

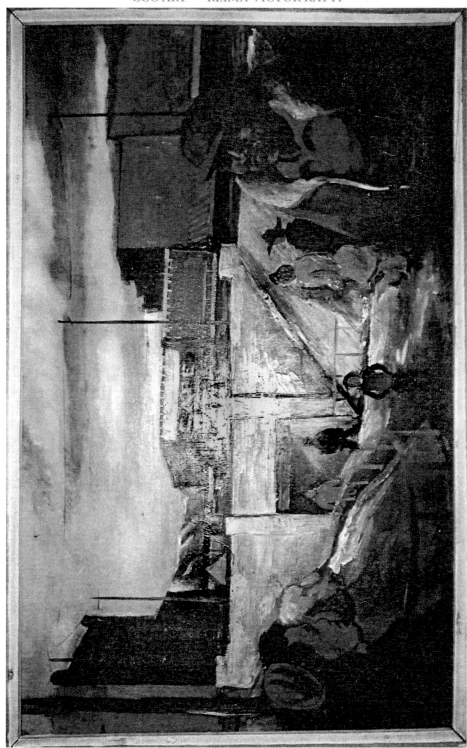

Rock Springs, Wyoming, courtesy Ratti family

Grain Elevator with Red Building by Ratti, oil on board

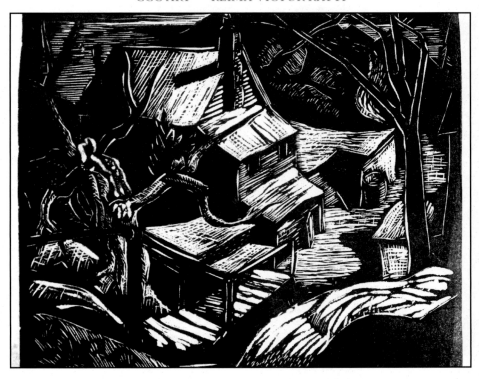

Untitled and undated works by Ratti: top, woodcut; bottom and facing page, sketches (Bess Bower Dunn Museum).

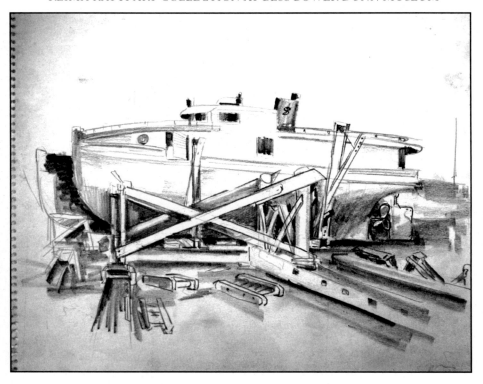

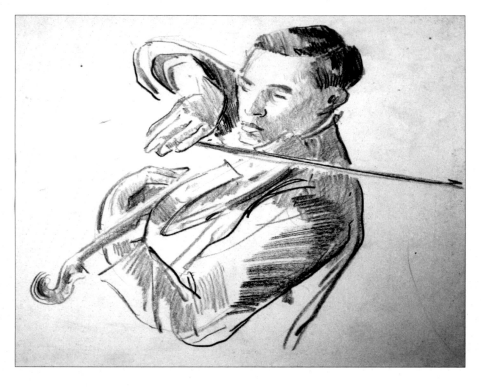

Black and white line art and portraits.

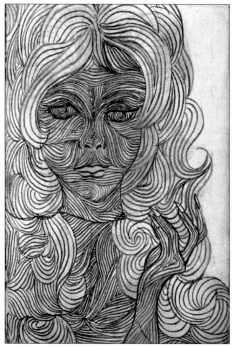

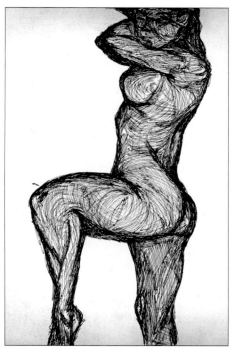

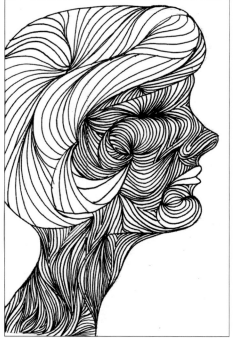

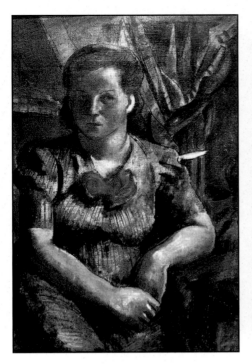

Top left: *A Woman's Portrait,* oil on canvas. Top right: sketch, possibly of a CCC enrollee. Bottom left: Portrait of *Man with Pipe,* oil on board. Bottom right: *Portrait of a Young Woman,* oil on board.

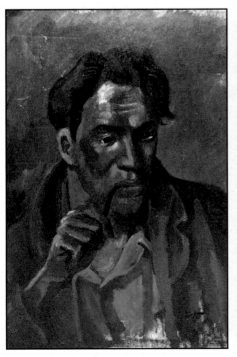
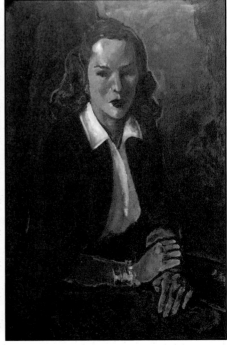

Untitled oil on canvas.

PART III

CCC STATUES
A BRIEF HISTORY

. . . a statue to remind posterity that
in a time of great need, the honest toil
of millions of youths salvaged the lands
and forests, meanwhile gaining
for themselves a newfound sense
of hope, dignity and self-worth. [179]

National Association of CCC Alumni
(NACCCA)

Chapter 21

Monumental Reminders

The NACCCA was founded in 1977 by several former CCC enrollees living in California. By 1983, when NACCCA celebrated the 50th anniversary of the CCC, they could boast multiple state chapters, a national headquarters and a museum in St. Louis, Missouri. Membership totalled over 22,000. After 30 productive years, NACCCA merged, with Camp Roosevelt CCC Legacy Foundation in August 2007 to become the CCC Legacy organization. Headquarters moved to Edinburg, Virginia. A clear objective from the group's inception was to honor the legacy of the CCC.

An early ambition of NACCCA was to identify the work of the CCC. *Operation CCC Identification* began. It resulted in countless numbers of plaques and markers placed in parks created or improved by the work of CCC.[180]

Mission: Recast a Statue

In 1992, empowered by a strong and active membership, a drive was begun by a NACCCA chapter in California. The goal was to "re-cast the (Palo-Kangas) art deco statue . . . similar in style to the Oscar of motion picture fame" and have that monument rein-stalled in Griffith Park, Los Angeles.[181]

This 1935 monument, as many CCC alumni were reminded, was unveiled by FDR. The following year, the repurposed statue mold was dedicated at the the International Pacific

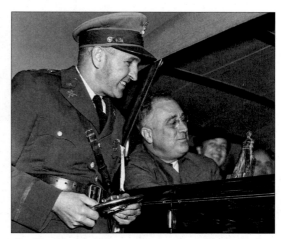

President Franklin D. Roosevelt, accompanied by First Lady Eleanor Roosevelt, holds a model of the *Spirit of the CCC* statue October 1, 1935, which was presented by Captain Lyston S. Black (left), commander of the Griffith Park CCC camp.

Exposition in San Diego. The identities of the statue went by many names: *Iron Mike, Conservation of Man and Nature, CCC Worker* and *Spirit of the CCC.*

NACCCA members were asked for their support in the *NACCCA Journal,* with articles on the statue history, and pledge envelopes were included in all newsletters.[182] Within 10 months, $23,135 in donations had been received, enough to make a reproduction of the Palo-Kangas *Spirit of the CCC* a reality, even if it did fall short of the $27,700 goal.[183]

Above: Sculptor Jim Brothers, 2003. Right: *Spirit of CCC* reinterpretation in Brothers' studio

Renowned sculptor Jim Brothers (1941–2013) of Lawrence, Kansas, was awarded the commission.[184] Having little to go on, except for a few photographs of the statues taken five decades earlier, Brothers described his sculpture, as a reinterpretation rather than a reproduction of the original *Spirit of the CCC.*[185]

Less than a year later, on October 1, 1993, the 10-foot monument was placed in the Travel Town Museum section of Griffith Park and dedicated.

One Statue in Every State

As the California chapter pursued its statue recasting project, NACCCA Chapter 129 in Grayling, Michigan, was moving forward with its version of a different CCC monument.

The chapter's goal was lofty. Members hoped to erect a monument typifying what they stated was an ideal CCC enrollee, and their aim was to place one statue in every state.

The Rev. William Fraser and other Michigan NACCCA members were inspired by a small, unsourced statuette in their collection of memorabilia. They correctly assumed it was created by a CCC boy, but what they didn't realize was what it symbolized and that it was created by a junior CCC enrollee while at a camp in Milwaukee.

This model statue appears to be one of the 1939 reproductions of Ratti's original 1936 *Days work done—C.C.C.* sculpture.

STATUE OF CCC BOY TO BE PLACED IN ST. PARK— Rev. William Fraser holds the statue of a typical Michigan, "CCC boy." The statue was commissioned by the National Association of Civilian Conservation Corps Alumni, and will be permanently placed within the North Higgins Lake State Park.

Unsourced, undated

Michigan chapter members agreed it typified the ideal CCC enrollee and envisioned a monument, a life-sized memorial cast in bronze, which they would name the *CCC Worker*.

A campaign was organized with other Michigan NACCCA chapters to create a reusable mold. The mission was to honor the CCC legacy by placing an identical statue in every state.

> *The CCC gave us dignity and self esteem . . .We learned to work in the CCC. This statue will make sure that the work of the CCC is remembered long after the last veteran is gone.* [186]

Rev. William Fraser

A 1995 collaboration began with the Elliot Gantz & Company foundry in Farmingdale, New York, for a design and reusable mold.

Using the Reima Ratti statue as a model and the Legacy group's ideas employee and sculptor Sergey Kazareyan designed the work.[187]

This new *CCC Worker* statue, was modified slightly from Ratti's original design. The right hand now held an ax rather than work gloves or protective goggles.

Rev. Fraser and the Michigan NACCCA chapter 129 engaged in good faith with a local intermediary, Derek McEvers, proprietor of a local funeral home in Grayling, Michigan. McEvers was not a CCC alumnus but was a member of the NACCCA chapter. Previously, McEvers had

Using the Ratti statue as a model, sculptor Sergey Kazareyan worked with the NACCCA Michigan chapter to create the *CCC Worker* statue.

placed orders for brass plaques used by Michigan NACCCA chapters to honor locations that benefitted from the work of the CCC.

All research indicates that the CCC alumni believed McEvers was acting on their behalf, but he apparently contracted independently, with the Gantz foundry in 1995, ultimately claiming ownership of the mold and its rights.

After the first *CCC Worker* statue was dedicated June 3, 1995 at North Higgins Lake State Park in Grayling, Michigan, NACCCA

members embraced this new purpose, "A statue in every state" became their motto and a new national goal.

For the next 12 years, NACCCA members rose to the *CCC Worker* statue challenge. To date, there are 73 *CCC Worker* statues in 40 states, with more being planned.

Campaign Endures

In 2017, the CCC Legacy organization procured the rights to the *CCC Worker* statue design and mold. Ownership, copyright, possession and the the goal of erecting a *CCC Worker* statue in every state is back in control of an organization whose objective is

to honor CCC history and to pass the CCC legacy to future generations. The organization's stated focus is on "a statue to remind posterity that in a time of great need, the honest toil of millions of youths salvaged the lands and forests, meanwhile gaining for themselves a newfound sense of hope, dignity and self-worth."[188]

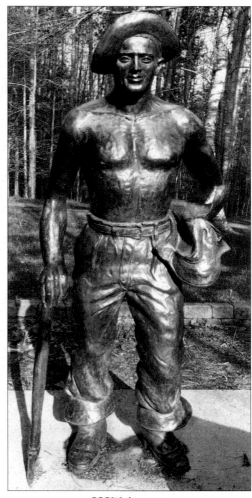

Long unrecognized is the romantic narrative and inspiration that sparked the monument's creation. It's a true tale of struggling young men and a New Deal artist Reima Victor Ratti, who created with his heart and soul. He was a fellow CCC member who, as one of them, found hope, dignity and self-worth in his *Day's Work Done C.C.C.*

CCC Worker statue,
Leonard Harrison State Park, Wellsboro, Pennsylvania

States with CCC Worker Statues

Alabama

Cheaha State Park

Arizona

Colossal Cave Mountain Park

Phoenix South Mountain Park

Arkansas

Devils Den State Park

Petit Jean State Park

Damascus

California

California Conservation Corps Hdqtrs

Colorado

Red Rocks Amphitheatre

Florida

Ft. Clinch State Park

Highlands Hammock State Park

Florida Caverns State Park

O'Leno State Park

Georgia

Franklin D. Roosevelt State Park

Iowa

Lacey Keosauqua State Park

Idaho

Central Idaho Historical Museum

Illinois

Willow Springs Forest Preserve Dst.

Giant City State Park

Indiana

Versailles State Park

Ouabache State Park

Kansas

Marion County Park

Crawford State Park

Kentucky

John James Audubon State Park

Louisiana

Kisatchie National Forest

Maine

Capitol Plaza, Augusta

Maryland

Gambrill State Park

Massachusetts

Freetown State Forest

Michigan

North Higgins State Park

Tahquamenon Logging Museum

Hartwick Pines State Park *

Minnesota

Flags of Honor Park, Willmar

Gooseberry Falls State Park

Missouri

Jefferson Barracks, St. Louis

Roaring River State Park

Montana

Lolo National Forest

Fort Missoula Regional Park

New Hampshire

Bear Brook State Park

New Jersey

School Conservation, Branchville

Roosevelt Park, Edison

New Mexico

Elephant Butte State Park

Capitol Grounds, Santa Fe

Bandelier Nat'l Monument

New York

Letchworth State Park

North Carolina

Singletary State Park

Pisgah National Forest

North Dakota

Fort Abraham Lincoln State

Ohio

Cuyahoga Valley Nat'Rec Area

Oregon

Forest History Center, Salem

Pennsylvania

Leonard Harrison State Park

Cascade Park, New Castle

Promised Land State Park

Laurel Hills State Park

Warren County Visitors Bureau

Pennsylvania Lumber Museum

Hyner Run State Park

South Carolina

Oconee State Park

South Dakota

Hill City Visitors Ctr- CCC Museum

Texas

White Rock Lake Park, Dallas, TX

Tennessee

Montgomery Bell State Park

Pickett CCC Memorial State Park

Cumberland Mtn St. Pk,Crossville

Utah

Salina, Utah

Zion National Park

Virginia

Shenandoah National Park

George Washington Nat'l Forest

Washington

Deception Pass State Park

Mt. Baker-Snoqualmie NR, Glacier

West Virginia

Watoga State Park

Cabwaylingo State Park

Wisconsin

Galloway House, Fond du Lac

Devil's Lake State Park

Trees for Tomorrow, Eagle River

Fox River Park

Wyoming

Guernsey State Park

* First statue to be dedicated

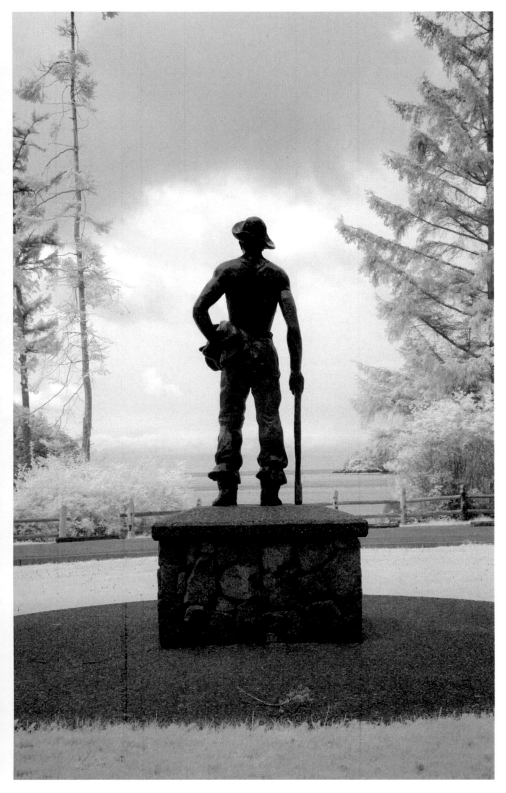

*The idea is not to
live forever,
but to create
something
that will.*

Andy Warhol

Chapter 22

Epilogue

Today, September 12, 2018, the expression "at rest" has a new meaning.

> *The law does not favor disinterment, based on the*
> *public policy that the sanctity of the grave should*
> *be maintained. Once buried, a body should not be*
> *disturbed.*[189]

In November 1945, when Ratti was interred in the northeast corner of the Pine View Memorial Park family and friends had every reason to believe this location would be a permanent and respected gravesite.

Ratti's life insurance policy envelope.

Ratti had a life insurance policy, coverage that presumably was used to provide a dignified funeral, the cemetery plot and unique stone marker whose design honors his artistic legacy.

Etched into Ratti's flat red granite gravestone are the words, "Son, Reima V. Ratti, 1914–1945," outlined by an artist's palette with two paintbrushes.

A red granite stone marked Ratti's not-so-final resting place at the Pine View Memorial Park, Beach Park, Illinois, in June 2018.

A June 2018 visit to the cemetery led to a shocking, surreal and haunting discovery about the artist's gravesite, however.

Shifting Ground

Beach Park, Illinois, on the banks of Lake Michigan, has sandy, porous soil. After investigation and eventually speaking with David B. Evans, deputy director of the Illinois Cemetery Oversight office, it was learned that in 2008 a new housing development adjacent to the cemetery created problems with runoff and soil erosion. Over time, the earth beneath the four graves to the right of Ratti's were undermined. In 2016, the embankment collapsed, washing the vaults containing their remains down a ravine that empties into a public waterway. Forced to act, Pine View Memorial Park authorities used a crane to haul up the vaults and rebury them in a safe location within the cemetery. Headstones needed to be replaced.

In June 2018, the author discovered the horrific condition of the Reima Victor Ratti's gravesite at Pine View Memorial Park in Beach Park, Illinois. It was on the verge of falling down a ravine. It appeared that his cement burial vault, partially visible in this image, is exposed due to significant soil erosion.

Since the 2016 embankment collapse, the ground that protected Ratti's vault, buried 10 feet from the surface in 1945, continued to destabilize, washing half of the nearby dirt down the deepening

ravine. The continued erosion exposed a portion of Ratti's vault and left it teetering on the edge.

The flat granite stone that marks Ratti's grave, an irreplaceable work of art, as found in June 2018, was also in danger of being washed away.

Authorities Notified

Author's note: In July 2018, United States Postal Service certified letters, return receipt requested, detailing the gravesite's condition along with the image of Ratti's exposed grave were sent to Illinois state, county and local authorities; the U.S. Army Corps of Engineers Chicago District; and the private owners of Pine View Memorial Park.

This correspondence briefly explained the remarkable story of a CCC artist, a painter, illustrator and sculptor who has done noble things for his country in addition to his contributions to the legacy of the greatest conservation movement in American history.

All were asked how they would rectify the dishonorable and disgraceful situation that had been allowed to continue since 2016.

Within weeks of posting these certified letters, authorities took action. The cemetery's authorities moved to obtain notorized permission from Ratti's family, in addition to filing for the required permits from the state of Illinois, and then to arrange for the services of a licensed funeral director, who would be present to supervise the disinternment and reinternment of Reima Victor Ratti.

On Wednesday, September 12, 2018, word was received that a safe and protected section within the Pine View Cemetery, far from the ravine, had been secured. Ratti was reinterred, the headstone was saved, and plans made to plant a grass covering. Ratti once again rests in a dignified grave.

May his art and legacy live on.

The new location for the grave of Reima Victor Ratti, at the Pine View Memorial Park, is now in Section 10, Lot 11, Grave #4.

Acknowledgements

The time expended to research and find the narrative, the art, the history and—in one shocking instance—in unearthing the conclusion of the Reima Victor Ratti story has been a decade in the making with tens of thousands of road miles traveled. It has been an exciting, heartbreaking, exhausting and inspirational journey of discovery.

First and foremost, I'd like to acknowledge George G. Duxbury, a CCC boy, and Mary Noonan, a legal secretary. They are the parents who instilled in me a love of this country and a firm belief in its checks and balances. Among the most memorable pearls of wisdom imparted by my mother were to "write it down and send it certified."

To the many scholars, authors, researchers, curators, museum directors, their assistants, clerks, librarians, historians, New Deal organizations, collectors, volunteers, archivists in the public and private repositories, private citizens who embrace the history and the friends and family of this remarkable CCC artist—some who are no longer with us—thank you.

To the family of Mary Jokenin Sadler, thank you for donating your mother's treasured collection of Ratti's art to the Bess Bower Dunn Museum. Diana Dretske, Dunn Museum curator, thank you for unrestricted access for research and imaging. To the niece and nephew who never met but cherish their Uncle Reima's memory, thank you. Cheryl "Rae" Coggins and Gary Ratti, your contributions have provided a better understanding of your family's struggles, history, and loyalty.

To CCC historians, researchers and collectors who have listened and openly shared their findings, may we all be successful in our desire to convey this history to future generations: Joan Sharpe,

president of CCCLegacy.org, for extended conversations and help as we puzzled through the CCC statue history; Naomi Shaw and Martha Smith for your cheerleading and support. Tim Montgomery, another "CCC baby," whose challenges of my research would help reinforce the findings and support the goal of procuring the rights to the *CCC Worker* statue, thereby insuring its honorable legacy, a huge thank you. To Kerry Bloedorn, CCC Museum in Rhinelander, Wisconsin; John Tabb, Pocahontas State Park CCC Museum historian, Kris Shenk, Jesse Bleemer of Unusual Finds and Kathy Tusing for images and copies of Ratti's CCC art. To Seth DePasquil, Isle Royale National Park historian, the 1936 graphic of the island you know so well is wonderful.

A warm thank you to Jon Bonnickson, for sharing in the excitement when the close friendship between your father, Ted, and Ratti was realized.

Thank you, also, to the dedicated archivists and technicians at the National Archives in College Park and St. Louis, Gene Morris, Kelsey Noel, Cara Lebonick , Whitney Mahar, Susan Nash and previously Tom Hayes and Ashley Mattingly.

Thank you to Caroline Sachay, U.S. General Services Administration, Chicago, and Jackie Schweitzer, Milwaukee Public Museum for help in solving the WPA/Ratti puzzle; Daniel Lee, Milwaukee Public Library, who graciously arranged a visit to the former Oriental Room, presumably the museum exhibit space where Ratti believed his mural(s) would be displayed; Beverly Millard, Waukegan Historical Society for her knowledge of early Waukegan life and author of Milwaukee's County Parks; and Laurie Muench (Albano) for her landscape architectural insight.

To those special CCC and New Deal authors, researchers, historians, scholars, those who dig deep to find and promote the history, you know who you are, thank you for your past, present and future endeavors that educate and inspire.

Important parts of this story would not have been possible without the contributions and easy-going explanations expressed by the late sculptor Jim Brothers. I'm saddened he did not live to see this story published.

Finding encouragement while interviewing four CCC artists will always remain the highlights of this research. Thank you, Frank Cassara; Ellsworth Handy; Jack Lewis; and my friend and sadly missed mentor, Charles C. Foster. And to the greatest generation CCC boys, those who have impressed upon us how times were different in the 1930s, to Peter Jacullo, Cosmo Zizzi, Lawrence Fowler, Walter Atwood, John Brennan, and the late Richard Chisinger, thank you.

I am grateful for all the new acquaintances made and the many longstanding ones revisited during this journey; colleagues who have given freely of their educated and artistic insights; friends who have rescued my partner and me during emergency repairs or given us peace of mind on stormy nights, travel advice, sanctuary in a driveway or barn. Thank you, you know who you are.

It has been a real pleasure to once again work with Jeannine Clegg, copy editor and adviser.

It bears repeating, that not one factoid or original image found for this story would have been possible without my research partner and fellow wanderer, Gardner Yeaw. Without exaggeration, you are the driving force behind the CCC artist research and our vintage, 35-foot, Bluebird Wanderlodge bus . . .

Bibliography

BOOKS

Adams, Henry H. *Harry Hopkins: The Life Story of the Man Behind FDR, the New Deal and Allied Strategy in World War II.* Putnam, 1977.

Albano, Laurie Muench. *Milwaukee County Parks.* Arcadia Publishing, 2007.

Allen, Frederick Lewis. *Only Yesterday An Informal History of the 1920s.* New York: Perennial Library, 1964. First published 1931 by Harper & Row.

——— *Since Yesterday: The 1930s in America, September 3, 1929— September 3, 1939.* New York: Perennial Library, 1986.

Asbell, Bernard. *The FDR Memoirs * As Written.* Garden City, NY: Doubleday & Company, 1973.

Biddle, George. *An American Artist's Story.* Boston: Little, Brown & Company, 1939.

Black, Allida M. *Casting Her Own Shadow: Eleanor Roosevelt and the Shaping of Postwar Liberalism.* New York: Columbia University Press, 1997.

Boettiger, John R. *A Love in Shadow—The Story of Anna Roosevelt and John Boettiger.* New York: W.W. Norton & Company, 1978.

Bradbury, Ray. *Dandelion Wine.* New York: Doubleday, 1957.

Bruce, Edward and Forbes Watson. *Art in Federal Buildings Volume I: Mural Designs, 1934–1936.* Washington, DC: Art in Federal Buildings, Inc., 1936.

Butler, Ovid, ed. *Youth Rebuilds: Stories of the CCC.* Washington, D.C.: American Forestry Association, 1934.

Clark, Lenore. *Forbes Watson: Independent Revolutionary.* Ohio: Kent State University Press, 2001.

Cohen, Adam. *Nothing to Fear: FDR's Inner Circle and the Hundred Days That Created Modern America.* New York: Penguin Press, 2009.

Contreras, Belisario R. *Tradition and Innovation in New Deal Art.* Lewisburg: Bucknell University Press, 1983.

Cook, Blanche Wiesen. *Eleanor Roosevelt: Volume One, 1884-1933.* New York: Viking, 1992.

——— *Eleanor Roosevelt: Volume Two, 1933-1938.* New York: Viking, 1999.

Cornebise, Alfred E. *Art from the Trenches: America's Uniformed Artists in World War I.* College Station: Texas A & M University Press, 1991.

———*The CCC Chronicles: Camp Newspapers of the Civilian Conservation Corps, 1933–1942.* Jefferson, NC: McFarland & Co., 2004.

Downey, Kirstin. *The Woman Behind the New Deal: The Life and Legacy of Frances Perkins, Social Security, Unemployment Insurance, and the Minimum Wage.* New York: Anchor Books, 2010.

Edsel, Robert M. *The Monuments Men: Allied Heroes, Nazi Thieves, and the Greatest Treasure Hunt in History.* Boston: Little, Brown & Company, 2013.

Farley, James A. Introduction to *When the New Deal was Young and Gay* by Charles Hurd. New York and London: Hawthorn Books, 1965.

Galbraith, John Kenneth. *The Great Crash, 1929.* Boston: Houghton Mifflin, 1988.

Galusha, Diane. *Another Day, Another Dollar, The Civilian Conservation Corps in the Catskills.* Hensonville, NY: Black Dome Press, 2009.

Geddes, Donald Peter, ed. *Franklin Delano Roosevelt: A Memorial.* New York: Pocket Books, 1945.

Goodwin, Doris Kearns. *No Ordinary Time: Franklin and Eleanor Roosevelt: The Home Front in World War II.* New York: Simon & Schuster, 1994.

Gordon, Colin, ed. *Major Problems in American History, 1920–1945: Documents and Essays.* Boston: Houghton Mifflin, 1999.

Guthrie, John D. *Saga of the CCC.* Washington, DC: American Forestry Association, 1942.

Hobson, Archie. *Remembering America: A Sampler of the WPA American Guide Series.* New York: Columbia University Press, 1985.

Hopkins, Harry L. *Spending to Save: The Complete Story of Relief.* New York: W.W. Norton & Company, 1936.

Hurd, Charles. *When the New Deal Was Young and Gay*. New York: Hawthorn Books, 1965.

Ickes, Harold L. *The Secret Diary Of Harold Ickes: The First One Thousand Days, 1933–1936*. New York: Simon & Schuster, 1954.

Krass, Peter. *Portrait of War: The U.S. Army's First Combat Artists and the Doughboys' Experience in WWI*. Hoboken, NJ: J. Wiley, 2007.

Kyvig, David E. *Daily Life in the United States, 1920–1940: How Americans Lived Through the "Roaring Twenties" and the Great Depression*. Chicago: Ivan R. Dee, 2004.

Lash, Joseph P. *Eleanor and Franklin: The Story of Their Relationship, Based on Eleanor Roosevelt's Private Papers*. New York: W.W. Norton & Co., 1971.

Lindsley, Chandler Roosevelt, ed. *Quotable Franklin*. New Brunswick, Canada: Chandler Roosevelt Lindsley and The Roosevelt Campobello International Park Commission, 2008.

Low, Ann Marie. *Dust Bowl Diary*. Lincoln: University of Nebraska Press, 1984.

Leuchtenburg, William E. *Franklin D. Roosevelt and the New Deal*. New York: Harper Collins, 1963.

McDonald, William Francis. *Federal Relief Administration and the Arts: The origins and administrative history of the arts projects of the Works Progress Administration*. Columbus: Ohio State University Press, 1969.

Maher, Neil M. *Nature's New Deal: The Civilian Conservation Corps and the Roots of the American Environmental Movement*. New York: Oxford University Press, 2008.

Melzer, Richard. *Coming of Age in the Great Depression: The Civilian Conservation Corps Experience in New Mexico, 1933–1942*. Las Cruces, NM: Yucca Tree Press, 2000.

O'Connor, Francis V. *The New Deal Art Projects: An Anthology of Memoirs*. Washington, DC: Smithsonian Institution Press, 1972.

Olson, James Stuart. *Historical Dictionary of the New Deal: From Inauguration to Preparation for War*. Westport, CT: Greenwood Press, 1985.

Pasachoff, Naomi E. *Frances Perkins: Champion of the New Deal*. New York: Oxford University Press, 1999.

Pasquill, Robert G. *The Civilian Conservation Corps in Alabama, 1933–1942: A Great and Lasting Good.* Tuscaloosa: University of Alabama Press, 2008. http://site.ebrary.com/id/10387694.

Perkins, Frances. *The Roosevelt I Knew.* New York: Viking Press, 1947.

Powell, Jim. *FDR's Folly: How Roosevelt and His New Deal Prolonged the Great Depression.* New York: Three Rivers Press, 2003.

Phillips, Sarah T. *This Land, This Nation: Conservation, Rural America, and the New Deal.* Cambridge: Cambridge University Press, 2007.

Purvis, Louis Lester. *The Ace In the Hole: A Brief History of Company 818 of the Civilian Conservation Corps.* Columbus, GA: Brentwood Christian Press, 1989.

Raban, Jonathan. *Bad Land: An American Romance.* New York: Vintage Books, Random House, 1997.

Rippelmeyer, Kay. *The Civilian Conservation Corps in Southern Illinois, 1933–1942.* Carbondale: Southern Illinois University Press, 2015.

Rodebaugh, Paul. *Waukegan, Illinois.* Arcadia Publishing, 2000.

Rollins, Alfred B., Jr. *Franklin D. Roosevelt and the Age of Action.* New York: Dell, 1960.

Roosevelt, Eleanor. *My Day.* Edited by Rochelle Chadakoff. New York: Pharos Books, 1989.

——— *The Autobiography of Eleanor Roosevelt.* New York: Da Capo Press, 1992.

——— *This I Remember.* New York: Harper & Brothers, 1949.

——— *This Is My Story.* New York: Garden City Publishing, 1939.

Roosevelt, Franklin D. *Fireside Chats.* New York: Penguin Books, 1995.

Roth, Benjamin. *The Great Depression: A Diary.* Edited by James Ledbetter and Daniel B. Roth. New York: Public Affairs, 2009.

Salmond, John A. *The Civilian Conservations Corps, 1933–1942: A New Deal Case Study.* Durham, NC: Duke University Press, 1968.

Schlesinger, Arthur M. *The Coming of the New Deal, 1933–1935.* Boston: Houghton Mifflin, 2003.

Smith, Page. *Redeeming the Time: A People's History of the 1920s and the New Deal.* New York: McGraw-Hill, 1986.

Steinbeck, John. *The Grapes of Wrath*. New York: Penguin Books, 1992.

Sypolt, Larry N. *Civilian Conservation Corps: A Selectively Annotated Bibliography*. Westport, CT: Praeger, 2005.

Terkel, Studs. *Hard Times: An Oral History of the Great Depression*. New York: New Press, 2000.

Townsend, Harry Everett, and Alfred E. Cornebise. *War Diary of a Combat Artist*. Niwot: University Press of Colorado, 1991.

Tweton, D. Jerome. *The New Deal At the Grass Roots*. St. Paul: Minnesota Historical Society Press, 1988.

Wilson, Eustis D and Shata Ling. *The Camp Life Workbook*. Atlanta, GA: Allen, James & Co., 1939.

Watkins, T. H. *Righteous Pilgrim: The Life and Times of Harold L. Ickes, 1874–1952*. New York: H. Holt, 1990.

Ziegelman, Jane, and Andrew Coe. *A Square Meal: A Culinary History of the Great Depression*. New York: Harper Collins, 2017.

PERIODICALS

Prigge, Matthew. "Seven Nights of Terror: Milwaukee's 'Mad Bomber' of 1935" *Wisconsin Magazine of History* 97, no. 3 (Spring 2014).

"Unemployment in the U.S." *Fortune* 10, no. 4 (October 1934): 54–61.

White, Margaret Bourke. "The Drought" *Fortune* 10, no. 4 (October 1934): 76–83.

NEWSPAPERS

Brown, Nelson C., "Forests and Men Benefited By the CCC: First Six Months of the Program Marked by Useful Work and Character-Building." *New York Times* (October 8, 1933).

"Obituary: James J. McEntee, Ex CCC Head Dies." *New York Times*, (October 16, 1957): L 35.

Skipper's Scandal, CCC camp newspaper, Camp Estabrook, co. 1699, Milwaukee, Wisconsin 1934 - 1937

ONLINE SOURCES

Ancestry. Birth, marriage, census, high school, and cemetery records of the Ratti family, their friends and neighbors. https://www. ancestry.com/.

Center for Research Libraries. *Skipper's Scandal* CCC Company 1699 Camp Estabrook newsletters, 1935–1937. https://dds.crl.edu/ crldelivery/16396.

Civilian Conservation Corps Facts, Lest We Forget," James F. Justin, last modified 2009, http://www.justinmuseum.com/famjustin/cccfacts. html and http://idahoptv.org/outdoors/shows/ccc/history/cccfacts.html.

Civilian Conservation Corps Legacy. "CCC Camp Lists." http:// www.ccclegacy.org/CCC_Camp_Lists.html.

———"CCC Statue List." http://www.ccclegacy.org/CCC_Statue_ List.html.

Columbia University Libraries Oral Histories Research Office. "Notable New Yorkers, Frances Perkins, Transcript, Part 4, Session 1, 1933–1934." Interviews by Dean Albertson: 510–514. http://www. columbia.edu/cu/lweb/digital/collections/nny/perkinsf/transcripts/ perkinsf_4_1_512.html; (OHRO/CUL) Last modified 2006.

Dretske, Diana. "Lake County, Illinois, History: Artist Reima Ratti (1914–1945)." Blog post, January 20, 2010. http://lakecountyhistory. blogspot.com/2010/01/reima-ratti.html

Gower, Calvin W., "The CCC Indian Division, Aid for Depressed Americans, 1933-1942," *Minnesota History*, Spring 1972, vol. 43, no. 1, last modified 2014, http://www.mnhs.org/market/mhspress/ minnesotahistory/featuredarticles/4301003-013/

Moser, Marvin, M.D. "Historical Perspectives on the Management of Hypertension." Wiley Online Library. First published May 22, 2007 in the *Journal of Clinical Hypertension.* https://onlinelibrary.wiley.com/ doi/full/10.1111/j.1524-6175.2006.05836.x.

O'Donnell, Kevin. "Isle Royale." Michigan State University. http:// geo.msu.edu/extra/geogmich/isleroyale.html.

National Park Reservations. "Isle Royale National Park: The History & Beauty of a Treasured Wilderness." https://www.nationalparkreservations.com/article/isleroyale-history-beauty/.

Paige, John C. *Civilian Conservation Corps and the National Park Service, 1933–1942: An Administrative History.* National Park Service,

Department of the Interior, 1985. https://www.nps.gov/parkhistory/online_books/ccc/index.htm (last modified April 4, 2000).

Prigge, Matthew J. "Seven Nights of Terror: The 1935 Bombing Spree of 'Idzy' Rutkowski." *Wisconsin Magazine of History* 97, no. 3 (Spring 2014). http://content.wisconsinhistory.org/cdm/ref/collection/wmh/id/51817.

Recorder of Deeds, Lake County, Illinois. Property Records Search. https://www.lakecountyil.gov/2341/Search-Property-Records.

Waukegan Historical Society. https://www.waukeganhistorical.org/.

Wisconsin Historical Society. "Civilian Conservation Corps (CCC) in Wisconsin." https://www.wisconsinhistory.org/Records/Article/CS2248.

— — — "Depression and Unemployment: Hard Times in Wisconsin." https://www.wisconsinhistory.org/Records/Article/CS426.

— — — "Milwaukee, Wisconsin History." https://www.wisconsinhistory.org/Records/Article/CS1607.

USDA Forest Service. "The First Century, The Great Depression Era, 1933–1942.". pg 66, https://www.fs.fed.us/sites/default/files/media/2015/06/The_USDA_Forest_Service_TheFirstCentury.pdf, revised April 2005, accessed 11/29/2018.

REPORTS

United States Department of the Treasury. *Public Works of Art Project. Report of the Assistant Secretary of the Treasury to Federal Emergency Relief Administrator.* December 8, 1933–June 30, 1934. Washington, DC: U.S. Government Printing Office, 1934.

Public Works of Art Project. Bulletin. Washington, DC: Public Works of Art Project, 1934.

THESIS

King, Roger L. "The Militarization of America's Youth: The Army and the Civilian Conservation Corps." Master's thesis, Army Command and General Staff College, 1993. http://www.dtic.mil/dtic/tr/fulltext/u2/a273956.pdf

Glossary

Acronyms for federal agencies, programs, repositories and organazations as they relate the Civilian Conservation Corps and the New Deal art programs. Followed by a glossary of names as they relate to the Reima Victor Ratti story and the history of the CCC statues.

Federal Agencies
CCC - Civilian Conservation Corps
ECW - Emergency Conservation Works Program see CCC
WPA - Works Progress Administration
PWAP - Public Works of Art Project
CWA - Civill Works Administration
FERA - Federal Emergency Relief Administration

Federal Repositories
NARA - National Archives and Records Administration
NACP - National Archives at College Park, Maryland
NASL - National Archives at St. Louis, St. Louis, Missouri

Organizations
CCC Legacy - Merged with NACCCA in 2007
NACCCA - National Association of CCC Alumni,see CCC Legacy

Glossary of names
 Austen, Carl – Waukegan artist friend of Reima
 Beatty, Clyde - Animal trainer Habenbeck-Wallace circus
 Black, Capt. Lyston S. – Commander 1935 Griffith Park CCC camp
 Blythe, June – Reporter *Waukegan Post* Staff
 Bonnickson, Ted – Waukegan high school friend, CCC artist
 Bradbury, Ray – Author Dandelion Wine, novel describing Greet Town
 Brothers, Jim – Sculptor, 1985 reinterpretation of "Spirit of CCC"
 Bruce, Edward – Director of the PWAP and the TSPS
 Bruenn, Dr. Howard G – FDR's physician
 Burns, George Thomas – CCC artist assigned to Camp Estrabrook
 Chavanek, Paul – Accomplice to Milwaukee bomber Rutkowski
 Coffman, John D. - Isle Royale, NPS Chief Forester, Fire Control
 Davis, Marshall – Staff artist for *HAPPY DAYS* and former CCC artist
 Drewniak, Joseph – Milwaukee Deputy Police Inspector
 Bess Bower Dunn Museum of Lake County Illinois, repository of Reima Ratti art
 Earhardt, Amelia – Pilot female across Atlantic Ocean
 East, Ben – Environmental Reporter *Grand Rapids Press*
 Endersbee, William J. – Isle Royale, Field Coordinator NPS
 Evans, David B. - Deputy Director of Illinois Cemetery Oversight office
 FDR – See Roosevelt, Franklin Delano

Fechner, Robert – Director of the CCC
Frazier, Rev. William- NACCCA CCC Worker statue program
Gantz, Eliott – Eliott Gantz & Co. foundry Farmingdale NY - *CCC Worker* statue
Hannon, William P. – Special Investigator CCC
Harju, Sulo – Student, sold, copied Reima's *Days Work Done* CCC statue.
Hellman, Roland – Waukegan high school artist friend, help build studio
Higley, Frances L – Director Art Department, WTHS
Hiibacka, Iver – Hilja Rattis brother, Reima's uncle Rock Springs, Wy.
Holm, Dr. Henry – Waukegan physician for Reima Ratti
Hoover, Herbert - 31st U.S. president - 1929-1933
Hoyt, Ray – Editor and owner *Happy Days* CCC newspaper
Jenstrom, Einar – Ratti family friend
Jickling, Charles A. – Poster Club Advisor, math teacher, WTHS
Joekenin, Mary – Fiancee of Reima Ratti
Just, Bernice – Reporter *News-Sun* Waukegan
Kazareyan, Sergey – Sculptor at Elliot Gantz foundry, *CCC Worker* statue
Lake County Historical Society – See Bess Bower Dunn Museum
Mackey, Donald –Art student, lived with Ratti family, art friend
MacLeish, Norman – Chicago WPA director of easel projects
McEntee, James – Asst. Director CCC
McEvers, Derek –Funeral Home Director, liasion for *CCC Worker* statue
McKinney, LaReine – Art Educator, WTHS
Moser, Dr. Melvin – Physician, specialist treatment. history Hypertension
Mylnarek, Patricia – child, victim – 1936 Milwaukee Bombing
Noonan, Fred – Navigator for Amelia Earhardt
Palo-Kangas, Uno John – Sculptor, 1935 *Spirit of CCC* statue
Perkins, Frances - Secretary of Labor - Roosevelt adminstration
Persons, W. Frank - Labor Department CCC representative
Ratti, Hilja – Mother Reima Ratti
Ratti, (Uno) Melvin – Brother Reima Ratti
Ratti, Victor – Father Reima Ratti
Roosevelt, Anna – Daughter of Franklin and Eleanor Roosevelt
Roosevelt, Eleanor – Wife of FDR, First Lady 1933 - 1945
Roosevelt, Franklin Delano – (FDR) 32nd US President 1933-1945
Rowan, Edward – Asst. Tech. Director PWAP and the TSPS
Rutkowski, Idzy Hugh Isador – 1936 Milwaukee dynamite bomber
Ryder, Melvin – Owner *Happy Days* CCC newspaper
Sadler, Mary Jokenin –- See Jokenin
Sauger, Capt. Frederick A. – CCC Comdr. Milwaukee Camp Estrabrook
Sparkes, Karen Sadler– Daughter of Mary Sadler
Stewart, Vernon Roy – CCC artist assigned to Camp Estabrook
Touminen, Hilja – See Hilja Ratti
Thomas, Capt. E. S. –Comdr. Isle Royale CCC camp at Rock Harbor
Toomajan, Dr. Harry – Waukegan physician for Victor Ratti
vonNeuman Sr., Robert Franz Albert – German born artist, taught Milwaukee
 Institute of Art (MIA)
Wallin, Frank G. – Mayor of Waukegan

About the Author

Kathleen Duxbury is a Civilian Conservation Corps researcher, historian and author. She is also the daughter of a former CCC boy. Over the last decade, she and her husband, Gardner Yeaw, have traveled more than 90,000 miles through the lower 48 states in their vintage Bluebird Wanderlodge motor home.

Researching this quiet part of American art history takes them to archives, libraries, universities, historical societies, museums, basements, attics and private homes, seeking the art and the stories. They prefer to visit and camp in the many state and national parks touched by the CCC and depicted by the artists. They meet with historians, interpretative rangers and archeologists in an effort to better understand this forgotten aspect of the New Deal.

Kathleen is a board member of the New Deal Preservation Association and has received recognition from the CCC Legacy organization for her CCC art research. She has authored two books on the CCC and numerous articles on the CCC art program. When not traveling, Kathleen and Gardner make their home in the northern-most part of the mid-Atlantic states.

Illustrations

Endnotes

1 W. Frank Persons, "Human Resources and the Civilian Conservation Corps (CCC)," Phi Delta Kappan, vol. 19, no. 9 (May 1937), 323–325.

2 Harold L. Ickes, The Secret Diary of Harold L. Ickes: The First Thousand Days, (New York: Simon & Schuster, 1954), 7; Alfred EmileCornebise, The CCC Chronicles, Camp Newspapers of the CivilianConservation Corps, 1933–1942, (North Carolina: McFarland &Company, Inc., 2004), 8–9; "Civilian Conservation Corps," Online Highways LLC, http://www.u-s-history.com/pages/h1586.html; "CCC Brief History," Civilian Conservation Corps Legacy, http://www. ccclegacy.org/CCC_Brief_History.html.

3 Frances Perkins, The Roosevelt I Knew, (New York: Viking Press, 1946), 177–181.

4 "Frances Perkins: Advocate for Working People, at FDR's Right Hand," Chapter 10 of II: Hope, Recovery, Reform: The Great Depression& FDR's New Deal, fdr4freedoms website, Franklin D. Roosevelt Four Freedoms Park, http://fdr4freedoms.org/hope-recovery-reform/#.

5 "Frances Perkins: Advocate," (see n. 4).

6 Frances Perkins, interview by Dean Albertson for the Columbia University Oral History Research Office, Columbia University Libraries (OHRO/CUL),Notable New Yorkers, Reminiscences of Frances Perkins, 1951 and1955, U.S. Department of Labor and the first year of the New Deal,Transcript Part 4, Session 1, 479–498, last modified 2006, http://www.columbia.edu/cu/lweb/digital/collections/nny/perkinsf/ transcripts/perkinsf_4_1_479.html.

7 Notable New Yorkers, Frances Perkins, Part 4, Session 1, 483, (see n. 6)

8 Notable New Yorkers, Frances Perkins, Part 4, Session 1, 494, (see n. 6)

9 Notable New Yorkers, Frances Perkins, Part 4, Session 1, 484, (see n. 6)

10 Notable New Yorkers, Frances Perkins, Part 4, Session 1, 487, (see n.6)

11 "Miss Perkins Defends Plan For Job Army," St. Louis Star and Times (St. Louis, Missouri), May 23, 1933, 1.

12 Notable New Yorkers, Frances Perkins, Part 4, Session 1, 494, (see n 6)

13 Notable New Yorkers, Frances Perkins, Part 4, Session 1, 492, (see n.6)

14 "USDA Forest Service. "The First Century, The Great Depression Era, 1933–1942.". pg 66, https://www.fs.fed.us/sites/default/files/media/2015/06/The_USDA_ Forest_Service_TheFirstCentury.pdf, revised April 2005, accessed 11/29/2018.

15 Perkins, *The Roosevelt I Knew,* 180–181.

16 Calvin W. Gower, "The CCC Indian Division, Aid for Depressed Americans, 1933-1942," Minnesota History, Spring 1972, vol. 43, no. 1, last modified 2014, http://www.mnhs.org/market/mhspress/minnesotahistory/featuredarticles/4301003-013/.

17 "CCC Brief History," Civilian Conservation Corps Legacy, last modified 2014, http://www.ccclegacy.org/CCC_Brief_History.html.

18 Roger L. King, "The Militarization of America's Youth: The Army and the Civilian Conservation Corps" (master's thesis, Army Command and General Staff Collection, Fort Leavenworth, KS, 1985), Army Heritage Center, Carlisle, PA, and Combined Army Research Library, Digital Library, Master of Military Art and Science Theses, call no. ADA 273956, last modified November 14, 2007, https://server16040.contentdm.oclc.org/cdm4/item_viewer.php?CISOROOT=/p4013coll2&CISOPTR=1211&CISOBOX=1&REC=3.

19 Gower (see n. 5).

20 "Civilian Conservation Corps Facts, Lest We Forget," James F. Justin, last modified 2009, http://www.justinmuseum.com/famjustin/cccfacts.html and http://idahoptv.org/outdoors/shows/ccc/history/cccfacts.html.

21 Notable New Yorkers, Frances Perkins, Part 4, Session 1, 512, (see n. 6), 510–514, last modified 2006, http://www.columbia.edu/cu/lweb/digital/collections/nny/perkinsf/transcripts/perkinsf_4_1_512.html.

22 Arthur M. Schlesinger, The Coming of the New Deal, 1933–1935 (Boston: Houghton Mifflin, 2003), 270.

23 Edward Bruce to Fiske Kimball, November 28, 1933, Fiske Kimball Papers, Philadelphia Museum of Art, FKR box 189, series 8, Works Progress Administration (WPA) and other relief programs, Subseries A, Pre-WPA programs, f.23, Post Public Works of Art Project (PWAP), Artist Relief programs, correspondence November–December 16, 1933.

24 Alfred Emile Cornebise, *The CCC Chronicles, Camp Newspapers of the Civilian Conservation Corps, 1933–1942* (North Carolina: McFarland & Company, Inc., 2004), 65–68.

25 Edward Bruce to CCC Director Robert Fechner, May 21, 1934, and Fechner's response to Bruce, May 22, 1934, 300 Records of the CCC, Entry 2, Box 734, PWAP general correspondence, 1933–1942, Record Group (RG) 35, National Archives at College Park, College Park, MD (NACP).

26 Donald B. Alexander memorandum to C.L.W. (Conrad L. Wirth), June 8, 1934; Arno B. Commerer (director) to Edward Bruce March 17, 1934, providing a list of National Parks for inclusion of artists, National Park Service Central Classified Files, File 0-618, Part 1, General public works artists, RG 79, NACP.

27 Bruce and Fechner correspondence, May 21 and 22, 1934 and June 4, 1934 (see n. 25). Bruce suggests employing artists as educational instructors, and Fechner responds after meeting with President Roosevelt and details FDR's suggestion. After meeting with his (CCC) advisory council, Fechner spells out how the CCC artist/enrollee program will be organized.

28 Rowan to Bruce, reporting on the status of the CCC artist program June 23, 1934, Rowan, Edward B.—1934, No. 2, Entry 124, Box 10, Records of the Public Buildings Service, RG 121, NACP.

29 Ibid. Memorandum from War Department Adjutant General's Office, Washington, D.C., to Commanding General, First Corps area, Army base, Boston, July 3, 1934.

30 Edward Rowan and CCC artist Stanley Dale correspondence, November 17, 1935, Dale, Stanley, Entry 142, Box 2, Records of the Public Buildings Service, RG 121, NACP.

31 Edward Rowan to Captain Richard H. Catlett (Company 351, Camp NF 8, Lyndhurst, VA), explaining the CCC art program, August 7, 1934, CCC Camps No. 2, Entry 106, Box 1, Records of the Public Buildings Service, RG 121, NACP.

32 Marriage certificate, Victor Herman Ratti to Hilja Tuominen, October 7, 1911, Waukegan, IL. Reima "Ray" Ratti collection donated by Karen Sparkes to, Bess Bower Dunn Museum, Libertyville, IL.

33 Recorder of Deeds, Lake County, IL, https://www.lakecountyil. gov/2341/Search-Property-Records, Mortgage Books, June 30, 1949, Document no. 673589, Book 930, Page 355, ... convey and release and quit-claim unto Victor and Hilja Ratti, ... all the rights, title, interest,-claim or demand... through a Trust Deed, bearing date August 7, 1923 no. 227945, mortgage book 300, 490.. On July 10, 1949 Hilja Ratti mortgaged the May Street house and ajoining lots.

34 Newton Bateman, Paul Selby and Charles Addison Partridge, eds., *Historical Encyclopedia of Illinois and History of Lake County* (Chicago: Munsell Publishing, 1902). Quoted at http://www.encyclopedia.chicagohistory.org/pages/1328.html.

35 Bateman, Selby and Partridge, http://www.encyclopedia.chicagohistory.org/pages/1328.html

36 "List Or Manifest of Alien Passengers For the United States Immigrations at Port of Arrival," October 8 1908, SS *Celtic* sailing from Liverpool October 16, 1908 to Port New York, Hilja Tuominan, line 12.

37 Ray Bradbury, "In His Words," http://www.raybradbury. com/ in hiswords02.html; Bradbury biographer Sam Weller, May 8, 2005, reply to Imskipper and Nard Kordell, http://raybradburyboard.com/ eve/forums/a/tpc/f/6891083901/m/7901041111

38 Ray Bradbury, *Dandelion Wine* (New York: Doubleday, 1957); circa 1921 photograph of a downtown Waukegan Lions Club parade, Waukegan Historical Society, Waukegan, IL.

39 CCC employment records, April 27, 1935, United States Department of Labor, Emergency Conservation Work Application Memorandum, Lake County Emergency Relief Committee, Waukegan, IL, CC6-146253, CCC Artist Reima Ratti, Civilian Personnel Records; National Archives at St. Louis, MO (NASL).

40 Reima Ratti receipt card, Waukegan Township Public Night School, Division of Shops, Commercial, Home Making and Related Subjects, October 1930, Reima Ratti collection of Kris Shenk.

41 "Big Double Circus Has Vast Program," *Cook County Herald* (Arlington Heights, IL), August 5, 1932; "This Is the Day the Circus Comes for Stay in City," *Chicago Tribune*, August 6, 1932.

42 "Circus Reports Record Crowds; Closes Tonight," *Chicago Tribune*, August 14, 1932.

43 Circus ad, *Rockford Register-Republic* (Rockford, IL), August 26, 1932, 5.

44 Ray Bradbury, "In His Words" (see n. 37).

45 "Hard Times in Illinois, 1930–1940: A Selection of Documents from the Illinois State Archives," Office of the Illinois Secretary of State, modified August 16, 2018, http://www.cyberdriveillinois.com/ departments/archives/teaching_packages/hard_times/home.html.

46 "Hard Times in Illinois," (see n. 45).

47 "I pledge you, I pledge myself, to a new deal for the American people." Franklin Roosevelt, Acceptance Speech, Democratic National Convention, July 2, 1932 https://fdrlibrary.org/dnc-curriculum-hub

48. Franklin Roosevelt Acceptance Speech, Democratic National Convention, July 2, 1932, https://fdrlibrary.org/dnc-curriculum-hub

49 "Prologue: Radio And The Great Depression," Making The Unreal Real: Radio Sound Effects In The 1930s (website), University of Virginia, last updated August 2, 2005, http://xroads.virginia.edu/~-ma05/macdonald/radiosfx/bg_radio_sfx.html.

50 Franklin D. Roosevelt Library (FDRL), First Carbon Files, 1933–1945, National Archives Identifier 197304

51 "Lake County Tax Raised 2 to 94 C per $100 Value," Chicago Tribune, January 12, 1933; Waukegan Township High School, 1933 yearbook, Waukegan, IL, Vol. 36, 90. "The Annual 'W' staff of 1933, perhaps the smallest in the past three years, was highly organized and capable of meeting the large demand by which they were confronted . . . Additional responsibility was placed upon the shoulders of the staff in order to publish the book three weeks ahead of time, due to the shortening of the term."

52 Waukegan High School annual, Waukegan Illinois, 1933 CIRCUS edition, Volume XXXVI, page 92

53 Cheryl Rae (Ratti) Coggins, June 27, 2016 interview. Coggins is granddaughter of Hilda Ratti, daughter of Melvin Ratti and niece of Reima Victor Ratti.

54 1930 U.S. Census, Victor Ratti.

55 Certificate of Sale, Lake County Recorder of Deeds, no. 531038, June 25, 1943, Book 8, 54. At a July 15, 1943 Lake County auction, Reima Ratti purchased the three May Street parcels his family lost due to forfeited general taxes from 1932 to 1941. His payment settled the liens and returned the property to the family.

56 1934 Rock Springs, Wyoming, directory; "Finn Relief Body Sends Clothing," Salt Lake Tribune (Salt Lake City, UT), October 3, 1940; Cheryl Rae (Ratti) Coggins, 2017 interviews.

57 June Blythe, "Baker By Night, Artist By Day, Waukegan Man Paints Beauty He Sees in Alley—Or Among Workers," Waukegan Post, May 3, 1940, collections of artist Carl Austen, Waukegan Historical Society, Waukegan, IL.

58 Reima Ratti letter to Edward Rowan, March 31, 1937, Entry 142, Box 5, Ratti, Reima Victor, RG 121, NACP.

59 1930 U.S. Census; CCC employment Records, Reima Victor Ratti, NASL; Station and Strength Reports, 1933–1942, PI 11 Entry 108, NAID 1102132, RG 35, NACP.

60 "Here Are the Winners of the News-Sun First Annual Carrier Championship Tournament," Waukegan News-Sun, January 31, 1934; Newspaper Delivery Bag exhibit at the Bess Bower Dunn Museum, Libertyville, IL, of a newspaper delivery bag used in the 1940s by 10-year-old Dick Price, a home delivery carrier, with 50 customers, for the Lake Zurich News Agency. The bag could carry all the Chicago, Elgin and Waukegan newspapers. "Each paper sold for a nickel, and he (Price) was paid a penny per paper for a weekly salary of $3."

61 Laurie Muench (Albano), *Milwaukee County Parks, Images of America* (Charleston, SC: Arcadia Publishing, 2007), 98.

62 Muench Albano, 99

63 "Flash!!," *Skipper's Scandal,* Company 1699, Camp Estabrook, Company 1699, June 3, 1937, Wisconsin Historical Society Library, University of Wisconsin Madison campus, CCC newspaper microfiche collections .

64 "County Aided By City Work" *Milwaukee Sentinel,* March 4, 1938.

65 "Ice In River and Creek Dynamited To Avert Flood—Ice Blasted by Dynamite, CCC Workers Work to Keep Water Flowing," *The Milwaukee Journal,* March 5, 1935, 1.

66 "Station and Strength Reports, 1933–1942," PI 11, Entry 108, NAID 1102132, RG 35, NACP.

67 *Skipper's Scandal,* April 30, 1935, 3.(see n. 63).

68 *Skipper's Scandal,* May 29, 1935, 8.(see n. 63).

69 "State Examination Ahead of Class in Dynamiting," *Skipper's Scandal,* May 29, 1935, 3.(see n. 63).

70"Project No. SP-5 (Wis)," *Skipper's Scandal,* March 1935, 5.(see n.63).

71 Robert Franz Albert von Neumann, Sr., (1888-1976), Museum of Wisconsin Art, http://www.wisconsinart.org/archives/artist/robert-franz-albert-von-neumann/profile-111.aspx.

72 CCC Employment Records, Reima Victor Ratti, NASL (see n. 39).

73 Jackie Schweitzer, WPA specialist at the Milwaukee Public Museum, email correspondence with author, March 17, 2018.

74 "Works Progress Exhibition of Art," *Milwaukee Journal Sentinel,* June 3, 1936.

75 Reima Victor Ratti, Chinese Jade Cutting, 1938, oil painting, 5-by-4-foot General Services Administration, (GSA)"RORALTI," FA847. GSA records have the name misspelled as "RORALTI" and also reflect the date as incorrect.

76 Chinese Jade Cutting, illustrating cutting jade with a wheel, locality, China, date depicted, 1900 A.D., fieldwork by and painted by Reima Ratti, Annex Hall 11, started January 1937, opened, June 1937, Mural no. A-123 catalog, Milwaukee Public Museum, Dept. Anthropology, Division Ethnology.

77. "President Forced To Delay His Trip," *Lansing State Journal* (Lansing, MI), September 18, 1935, 14.

78 "Informal extemporaneous remarks of the President at the unveiling of the statue erected by CCC Transient Camp, Griffith Park, Los Angeles, California," October 1, 1935, FDRL, Hyde Park, NY. "This is a transcript by the White House stenographer (unreadable), his shorthand notes taken (unreadable) as the speech was made."

Author's note: It was at the Griffith Park CCC camp that FDR unveiled the statue. His motorcade would next visit a "boys camp."

79 Special CCC Investigative Report by William P. Hannon, November 13, 1935, CCC Camp 1699 investigative report; entry 115, box 236, folder Wisconsin, CP-2, Milwaukee, formerly SP-5; RG 35; NACP. CCC Assistant Director Robert McEntee ordered a special investigation into the theft of CCC dynamite and the subsequent bombings. Special investigator William P. Hannon produced a three-page report after an intensive on-site inspection.

80 "Fake Squad Car With Four Bombs Found By Milwaukee Police," *Green Bay Press-Gazette* (Green Bay, WI), December 6, 1935, 2.

81 "Lost Milwaukee #2 . . . Eight Days of Terror in 1935," Historic Milwaukee Incorporated (blog), February 9, 2011, http://historicmilwaukee.blogspot.com/2011/02/lost-milwaukee-2-eight-days-of-terror.html.

82 "Blast Set Off At Shorewood Village Hall: Felt In Estabrook Park" *Milwaukee Sentinel,* October 27, 1935, 6-A.

83 *"Blast Felt in Estabrook Park," October 27, 1935, 6-A.*

84 " Two Branch Banks Bombed in Milwaukee; Hunt Fugitive's Car," *Green Bay Press-Gazette,* October 28, 1935, 2.

85 "43 Suspects Caught In Police Dragnet," *Marshfield News Herald* (Marshfield, WI), November 2, 1935, 3.

86 "Abandoned Car Yields Bomb" *The Journal Times* (Racine, WI), December 6, 1935, 1.

87 Lois M. Quinn and John Pawasarat, "History of Jobs for Workers on Relief in Milwaukee County, 1930–1994," ETI Publications, Paper 157, University of Wisconsin Milwaukee (UWM) Digital Commons (website), 1994, http://dc.uwm.edu/eti_pubs/157.

88 CCC Camp 1699 investigative report (see n. 79).

89 Special CCC Investigative Report by William P. Hannon, November 13, 1935, Entry 115, Box 236, Folder Wisconsin, CP-2, RG 35, NACP (see n. 79); Matthew J. Prigge, "Seven Nights of Terror: the 1935 Bombing Spree of 'Idzy' Rutkowski," Wisconsin Magazine of History, Spring 2014, 39.; Kathryn A. Flynn, The New Deal: a 75th Anniversary Celebration with Richard Polese (Layton, Utah: Gibbs Smith, 2008), CCC Alumni Chapter 141, Albuquerque, New Mexico:
"Requirements for acceptance were basic: between the ages of 18–25 later changed to 17–29, physical requirements were between 5–6 feet, 6 inches tall, weigh more than 107 pounds, have no communicable diseases and have at least three serviceable and natural masticating, teeth. In reality, one worker noted, 'all the government really wanted was our bodies for the work ahead.' "

90 "Earlier Clashes With Law Made Bomber Hate Police: Revenge Seen As His Motive," *The Milwaukee Journal*, November 4, 1935, 1, 2.

91 "586 Pieces of Explosive Stolen Here Since 1933," *Milwaukee Journal*, November 6, 1935, 1.

92 "Thieves Knew Park's Layout," *The Milwaukee Journal*, November 2, 1935, 1, 2.

93 "Explosion Damage May Reach $100,000," *Milwaukee Sentinel*, November 4, 1935, 4.

94 "Two Killed in New Blast; Believe Bomber a Victim" *The Milwaukee Journal*, November 4, 1935, Extra edition, 1.

95 George Thomas Burns, CCC Employment Records, NASL; RG 121, Records of the Public Building Service, Entry 142, Box 1, Correspondence with artists in CCC camps 1934–1937, NACP.

96 Burns, CCC Employment Records.

97 Vernon Roy Stewart, CCC Employment Records, NASL; Correspondence with artists in CCC camps 1934–1937, Records of the Public Building Service, Entry 142, Box 5, RG 121, NACP.

98 *The Milwaukee Journal*, March 29, 1936, 127.

99 "Memories of Isle Royale—Conclusion," *Skipper's Scandal*, May 1937, 5. Wisconsin Historical Society Library, Univ. Wisconsin in Madison, Wisconsin, CCC Camp newspaper microfiche collection. (see n. 63).

100 Charles A. Symon, "That Jewel in Lake Superior," in *We Can Do It, A History of the CCC in Michigan 1933-1942* (Escanaba, MI: Richards Printing, 1983), 85.

101 Henry L. Hansen, Lauritis W. Krefting and Vilis Kurmis, "The Forest Of Isle Royale In Relation To Fire History and Wildlife," Agricultural Experiment Station, University of Minnesota, Technical Bulletin 294, Forestry Series 13, October 1973, 13, 49972_hansen_et_al_1973; downloadable from https://www.frames.gov/catalog/5782.

102 Hansen, Krefting and Kurmis, 14.

103 John Davis (son of Clarence Marshall Davis) interview, correspondence and telephone conversations with author, 2010–2014.

104 Davis, 2010–2014.

105. Philip V. Scarpine, "Isle Royale National Park: Balancing Human and Natural History in a Maritime Park," The George Wright Forum, *Environmental History in National Parks* 28, No. 2 (2011): 192.

106 Jack VanCoevering, "Woods and Waters: Isle Royale Fire," *Detroit Free Press*, September 23, 1936, 25.

107 Harold L. Ickes, "Annual Report of the Secretary of the Interior 1936-1937," Conservation activities, 41, accessed February 4, 2018, https://babel.hathitrust.org/cgi/pt?id=uc1.32106020212061;view=1up;seq=77.

108 "Recruits Rushed Into Forest Fire Areas of North," *Times Picayune* (New Orleans, LA), August 11, 1936, 1.

109 "Memories of Isle Royale," *Skipper's Scandal,* March 1937, 3; entry 142, box 5, Reima Ratti; RG 121; NACP.

110 *Skipper's Scandal,* March 1937, 3, (see n. 63)

111 *Skipper's Scandal,* March 1937, 3, (see n. 63)

112 "Mainland Fires Rage," *Grand Rapids Press* (Grand Rapids, MI), August 16, 1936, 1; Ben East Papers 1935–1980; "Fire 1936", Call No. 0744 Aa 2, box 13; Bentley Historical Library, University of Michigan.

113. *Grand Rapids Press,* August 16, 1936, 1.

114 Ben East, "Isle Royale Fire Leaves Devastation in Its Wake," *The Wakefield News* (Wakefield, MI), September 12, 1936, 2.

115. East, September 12, 1936, 2.

116. East, September 12, 1936, 2.

117 *Skipper's Scandal,* March 1937, 3.(see n. 63).

118 "Isle Royale," *Skipper's Scandal*, Spring (April) 1937, 5.(see n. 63).

119 "Memories of Isle Royale—Conclusion," *Skipper's Scandal,* May 1937, 5; Correspondence with Artists in Civilian Conservation Corps Camps, 1934–37; entry 142, box 5, R-S; RG 121; Records of the Public Buildings Service, Section of Fine Arts; Public Buildings Administration and its predecessors, NACP. also (see n. 63).

120 Seth DePasqual, cultural resource manager, National Environment Policy Act (NEPA) specialist, Isle Royale National Park, Houghton, MI, interview with author, February 2018.

121 *Skipper's Scandal,* May 1937, 5.(see n. 63).

122. William P. Hannon, "Civilian Conservation Camp InspectionReports, RG 35 , entry 115, box 104, Houghton, Michigan, NP-1, August 26, 1937, Company 2613, Camp Siskiwit; NACP

123. Hannon, "Emergency Conservation Work" (see n. 122).

124 Reima V. Ratti, Individual Civilian Conservation Corps Record; NASL

125 "Memories of Isle Royale Conclusion," Skipper's Scandal, May 1937, 5; Ratti sent selected copies of the Skipper's Scandal to Edward Rowan, Correspondence with Artists in Civilian Conservation Corps Camps, 1934–37 (see n. 63 and n. 119).

126 Reima Ratti, letter to Edward B. Rowan, September 19, 1936; Correspondence with Artists in Civilian Conservation Corps Camps, 1934–37; entry 142, box 5, R-S; RG 121; Records of the Public Buildings Service, Section of Fine Arts; Public Buildings Administration and its predecessors, NACP.

127 Kristopher Shenk, Isle Royale memorabilia collector and repeat Isle Royale National Park backpacker/camper, interview with author, July 8, 2018.

128 Reima Ratti, letter to Edward B. Rowan, September 19, 1936; Correspondence with Artists in Civilian Conservation Corps Camps, 1934–37; entry 142, box 5, R-S; RG 121; Records of the Public Buildings Service, Section of Fine Arts; Public Buildings Administration and its predecessors, NACP.

129 Ratti letter to Rowan, September 19, 1936.(see n. 128).

130 J.W. Higgins, "The Superintendent Suggests," *Skipper's Scandal,* March 1937, 1.(see n. 63).

131 Reima Ratti, letter Rowan, March 13,1937 (see n. 128).

132 Ratti informs Rowan of his artistic activities(see n. 128).

133. "Flash!!," *Skipper's Scandal,* Company 1699, Camp Estabrook, June 3, 1937; Company 1699, (see n. 63).

134 Reima Ratti, letter Rowan, September 3, 1937. Correspondence with Artists in Civilian Conservation Corps Camps, 1934–37; entry 142, box 5, R-S; RG 121; Records of the Public Buildings Service, Section of Fine Arts; Public Buildings Administration and its predecessors.

135 Rowan, Edward B. to Jack W. Higgins, superintendent, Estabrook Park, Milwaukee, WI, August, 4, 1937, Ratti folder, Correspondence with Artists in Civilian Conservation Corps Camps, 1934–37; entry 142, box 5, R-S; RG 121; Records of the Public Buildings Service, Section of Fine Arts; Public Buildings Administration and its predecessors, NACP.

136 RG 121-CCC Artist Card Index File, Still Picture Research Room card file, NACP.

137 "Barrack Gossip," *Skipper's Scandal,* June 3, 1937, 4, (see n. 63); Rowan, Edward B. to Jack W. Higgins, superintendent, Estabrook Park, Milwaukee, WI, August, 4, 1937; Reima Ratti to Edward Rowan, September 3, 1937 (see n. 135).

138 Reima Ratti, letter Rowan, March 13, 1937 (see n. 125).

139 RG 121-CCC Artist Card Index File, (see n. 135).

140 RG 121-CCC Artist Card Index File, (see n. 135).

141 June Blythe, "Baker By Night, Artist By Day" (see n. 57).

142"China's Delay Irks Japan," *The Milwaukee Journal,* July 18, 1937, 1,3.

143 "Wants Amelia Search Data: Representative Asks Full Accounting On Search of Lost World Fliers" *The Milwaukee Journal,* July 18, 1937, 1,2.

144 Blythe, "Baker By Night, Artist By Day" (see n. 57).

145 Unsourced news article provided by the Waukegan Historical Society collection of newspaper clippings, circa 1939.

146. Unsourced news article, circa 1944, Scrapbook Album, 2005.19.163, Reima Victor Ratti collection, Bess Bower Dunn Museum, Libertyville, IL. Scrapbook has notations possibly made by Ratti fiancée Mary (Perusky, Jokenin) Sadler, who remarried in 1949.

147 1940 U.S. Census.

148 Blythe, "Baker By Night, Artist By Day" (see n. 57).

149 Jessie Murphy, "Visiting Artist Paints Scenes of Rock Springs," unsourced news article, circa November 1944, Scrapbook Album 2005.19.162, Reima "Ray" Ratti collection, Bess Bower Dunn Museum, Libertyville, IL.

150 CCC statue with 1936 Harju copyright, 2017 eBay purchase, author's collection; "Redgranite Chips," Oshkosh Northwestern (Oshkosh, WI), 15, "Sulo Harju of this village is attaining considerable fame for the souvenir statues he has been modeling of a CCC worker and called A Day's Work Done. He is engaged in that work to raise money to continue his studies at the state university."

151 1940 U.S. Census.

152 Unsourced news article, Carl Austen collection, Reima "Ray" Ratti collection, Bess Bower Dunn Museum, Libertyville, IL.

153. "Army Barracks On the Pacific," *Chicago Sunday Tribune*, August 14, 1944, N Part 3, 2; "Tim Mackey's Brother Honored," *Sunday Register-Star* (Rockford, IL), March 29, 1970, Family, Section C.

154 Cheryl Rae Ratti Coggins, niece of Reima Ratti, telephone interviews and correspondence with author, 2016–2018.

155 Reima "Ray" Ratti Collection, 2004.19, Karen Sparks donation, Bess Bower Dunn Museum, Libertyville, IL; Selective Service Records Reima Victor Ratti, NASL.

156 Cheryl Rae (Ratti) Coggins interviews.

157 Lake County Recorder of Deeds, Waukegan, IL, File 503145, October 10, 1941, Grantor Lester F. Collins, Grantee Reima Ratti, Lot 10, Block 45, Page 12.

158 Lake County Recorder of Deeds, File 531038, Certificate of Sale, Grantor National Fire Works Ins. Co. by County Treasurer, Grantee Reima Ratti, $200, Nixons subdivision Lots 26, 27, 28.

159 Lake County Recorder of Deeds, File 531038.

160 Murphy, Jesse, "Visiting Artist Paints Scenes of Rock Springs" (see n. 149).

161 Just, Bernice, "*Odd Pieces*, an Art Collection of Love," *News-Sun* (Waukegan, IL), February 16, 1976, A6, included in this article is a

photograph of this oil with its title. Reima "Ray" Victor Ratti collection, Bess Bower Dunn Museum, Libertyville, IL.

162 Marvin Moser, M.D., "Evolution of the Treatment of Hypertension From the 1940s to JNC V," American Journal of Hypertension (AJH) 10 (1997): 25–85, Oxford University Press, published online by Elsevier Science, Inc.; Clinical notes on the illness and death of President Franklin D. Roosevelt, Annals of Internal Medicine 72, no. 4 (April 1970): 579–91.

163 Death certificate, Reima Victor Ratti, Nov. 16, 1945, signed attending homeopathic physician Henry Holm, Waukegan, IL, who treated Ratti for "hypertension."

164 Marvin Moser, M.D., "Historical Perspectives on the Management of Hypertension," Journal of Clinical Hypertension, 8 no. 8 (August 2006): 15–20, published online May 22, 2007, https://onlinelibrary.wiley.com/doi/abs/10.1111/j.1524-6175.2006.05836.x.

165. Moser (see n. 164).

166 Moser (see n. 164).

167 Moser (see n. 164).

168 Cheryl Rae (Ratti) Coggins, interviews with author, 2017. The family was told Ratti died of kidney failure; "How High Blood Pressure Can Lead to Kidney Damage or Failure" American Heart Association, last updated September 15, 2017, http://www.heart.org/HEARTORG/Conditions/HighBloodPressure/LearnHowHBPHarmsYourHealth/How-High-Blood-Pressure-Can-Lead-to-Kidney-Damage-or-Failure_UCM_301825_Article.jsp#.WrkGSejwbIU.

169 Death certificate, Reima Victor Ratti, Nov. 16, 1945.

170 Rose L. Evans letter of condolence to Mary Jokenin, November 23, 1945, Reima "Ray" Ratti collection, Bess Bower Dunn Museum.

171 Unsourced news article, circa 1944, Reima "Ray" Ratti collection, Bess Bower Dunn Museum.

172 Labor Daily (Sydney: Australia), October 7, 1953, unsourced published article, courtesy of Cheryl Rae (Ratti) Coggins

173. Labor Daily, October 7, 1953.

174 Melvin and Hilja Ratti letters to Mary Sadler and others, July 19, 1954 and November 28, 1954, Reima "Ray" Ratti Collection, 2004,19, Karen Sparks donation, Bess Bower Dunn Museum, Libertyville, IL.

175. Tax deed, Interstate Bond Company, Chicago, Illinois 1029112, book 1701, 366, Lake County Recorder of Deeds, Waukegan, IL.

176 Just, "Odd Pieces, an Art Collection of Love," (see n. 161).

177 Just, "Odd Pieces, an Art Collection of Love," (see n. 161).

178 Einar Jenstrom letter to Mary Sadler, August 27, 1991, Reima "Ray" Ratti collection, Bess Bower Dunn Museum, Libertyville, IL.

179 Arthur G. Kerle, "Rev. William Fraser Honored For Statue Program," *NACCCA Journal*, April 2002, 12.

180 "Civilian Conservation Corps—a government work program rescued the common men in the 1930s,", *California Historian* article, www.californiahistorian.com/articles/civilian-conservation-corps.html (page discontinued) but can be viewed using the Internet Archive Wayback Machine, https://archive.org/web, and entering the above California Historian web address and accessing the November 8, 2008 screen capture.

181 "Chapter 55 Appeals: Help Us Bring Back Iron Mike," *NACCCA Journal* 8, nos. 11 and 12 (1985): 11; "$12,000 Still Needed to Re-Sculpt CCC Statue," *NACCCA Journal* 16, no. 5 (March 1993): 8.

182 "Members Support Sought for CCC Statue, Pledge Envelopes in This Issue of *Journal*," *NACCCA Journal* 16, no. 2 (December 1992): 8

183. "The Spirit of the CCC," *NACCCA Journal*, 16, no. 12 (October 1993): 1.

184 "NACCCA To Replace Statue The 'Spirit of the CCC'," *NACCCA Journal* 16, no. 1 (November 1992): 12.

185 Jim Brothers email to author, February 8, 2012.

186 Rev. William Frasier quoted by Pierce, Mike, Editor, "CCC Statue Dedicated in Michigan", *NACCCA Journal* 4 no. 8 (August 1995): 1.

187 William Kibler, "Area Man Hopes to Fund CCC memorial," *Altoona Mirror* (Altoona, PA), September 13, 2010, 1, 6; *Altoona Mirror* reporter William Kibler telephone conversation with author, October 25, 2015.

188 Kerle, "Rev. William Fraser Honored For Statue Program." (see n. 179)

189 Corpse - Rights To Disinterment, "http://law.jrank.org/pages/5776/Corpse-Rights-Disinterment.html".

Index

C

R

S

T

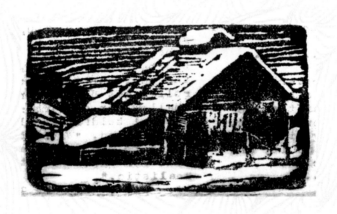

Made in the USA
Monee, IL
17 December 2019

18873521R00121